WHISPERED PRAYERS

Portraits and Prose of Tibetans in Exile

PUBLISHED BY

Talisman Press, LLC
PMB 270, 1324 State Street, Santa Barbara, California 93101

Whispered Prayers: Portraits and Prose of Tibetans in Exile
Text and Photography by Stephen R. Harrison

Edited by Gail M. Kearns, GMK Editorial & Writing Services, Santa Barbara, California
Copyedited by Barbara Coster, Cross-t.i Copyediting, Santa Barbara, California
Initial Book Concept Design by Matt Hahn, ThinkDesign, Buellton, California

Publisher's Cataloging-in-Publication
(Provided by Quality Books, Inc.)
Harrison, Stephen R., 1943-
Whispered prayers : portraits and prose of Tibetans
in exile / photographs and text by Stephen R. Harrison ;
foreword by his holiness the fourteenth Dalai Lama ;
essay by Anthony Storr ; essay by Vicki Goldberg. — 1st ed.
p. cm.
ISBN 0-9667261-1-1
1. Political refuges — China — Tibet — Interviews.
2. Political refugees — China — Tibet — Pictorial works.
3. Tibet (China) — Exiles — Interviews.
4. Tibet (China) — Exiles — Pictorial works.
I. Bstan-'dzin-rgya-mtsho, Dalai Lama XIV, 1935-
II. Title
HV640.5.T5H37 1999 362.8'7'089954
QBI99-559

Design, Digital Production and Printing by www.media27.com, Santa Barbara, California
Printed and bound in the United States of America

WHISPERED PRAYERS

PORTRAITS AND PROSE OF TIBETANS IN EXILE

PHOTOGRAPHS AND TEXT BY STEPHEN R. HARRISON

FOREWORD BY HIS HOLINESS THE FOURTEENTH DALAI LAMA

ESSAY BY ANTHONY STORR
ESSAY BY VICKI GOLDBERG

TALISMAN PRESS

Santa Barbara, California

THIS BOOK IS DEDICATED

TO REFUGEES THE WORLD OVER

AND TO THE NOBILITY

OF THE HUMAN SOUL

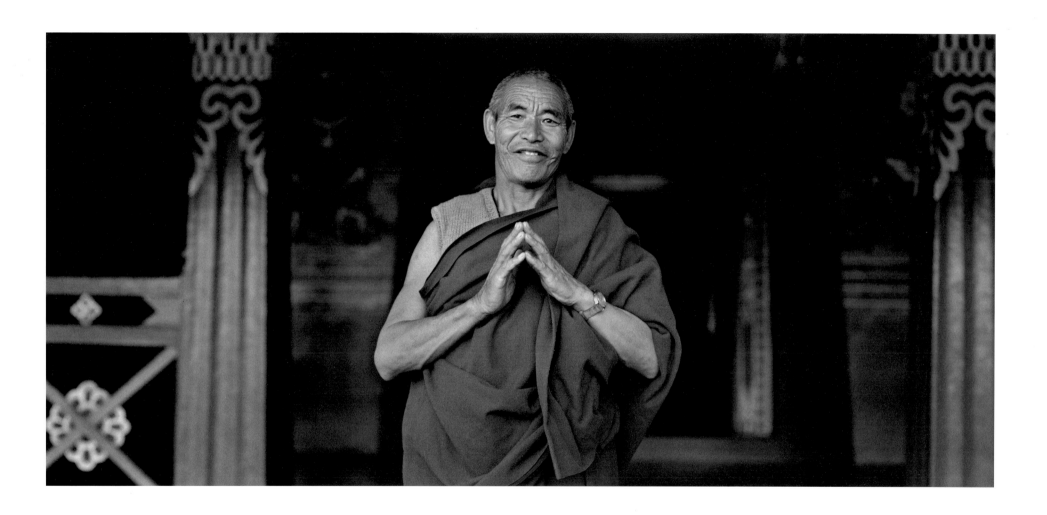

Tibetan Priest

TABLE OF CONTENTS

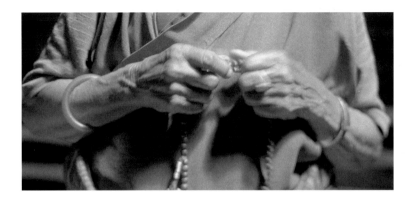

FOREWORD

As a result of the present sad history of Tibet, there is hardly any Tibetan family that has not lost their dear ones or undergone suffering. Every Tibetan has a story to tell that is traumatic in content, but most end with a sense of hope for the future. This book by Stephen Harrison has given individual Tibetans of varying ages the opportunity to share with a wider audience their personal sad experiences and their responses to them. I am encouraged to learn that after patiently listening to these stories, Dr. Harrison has discovered the "radiant lightheartedness, generosity, kindness and compassion" of these Tibetans, despite their traumatic experience of life under Chinese rule.

I am deeply moved by both the words and images encapsulated in this book. Focusing on the lives of Tibetans who have undergone tremendous suffering, the book succeeds in portraying the courage and dignity of the people of Tibet.

It is my sincere hope that such books will convince readers of the urgent need to end the suffering of the Tibetan people and that their influence will come to bear on the international community and the Chinese leadership. There are signs that this may happen. China's recent signing of the UN Covenant on Civil and Political Rights may signal that in some not too distant future China will respect the fundamental rights and freedoms of not only the Chinese people but even the Tibetans too.

His Holiness the Fourteenth Dalai Lama
Dharamsala, October 20, 1998

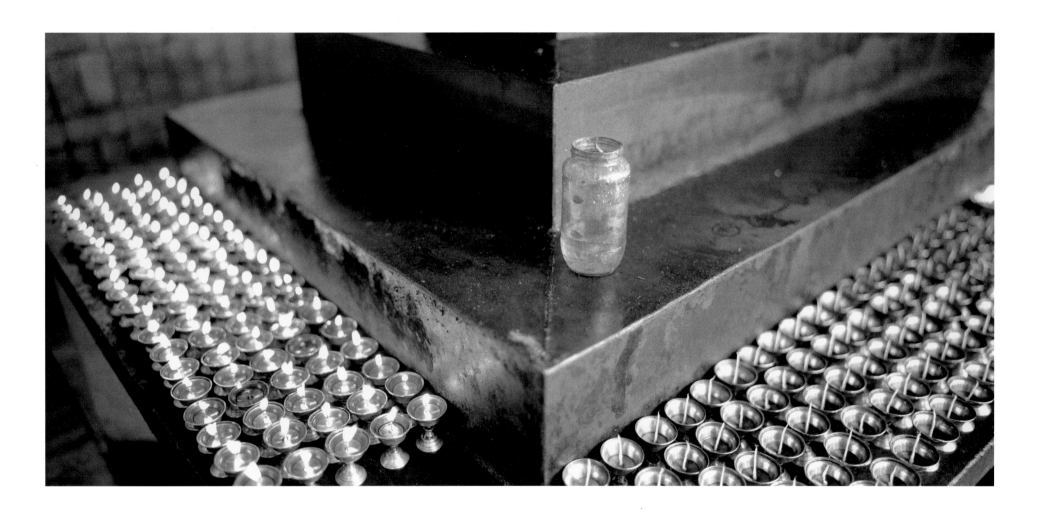

Butter Lamps, Mussoorie, India

Essay by Anthony Storr

So many horrors have occurred during this twentieth century that we are in danger of forgetting all but the very recent. Dr. Harrison's book is a timely reminder of one of the most brutal: the recurrent invasions of Tibet by Communist China from 1950 onward. The barbarians who perpetrated this attempt to destroy an ancient culture pillaged and burned the monasteries, caused the death of over a million Tibetans, made exiles of the Tibetan Government, the Dalai Lama and thousands of his followers, and treated those Tibetans who remained behind with sickening cruelty.

Dr. Harrison's photographs of, and interviews with, some of those Tibetans who managed to escape to India constitute a poignant collection of personal records which illustrate these terrible events in a vivid way which no scholarly history can match. One monk tells of spending thirty-three years in Chinese prisons and labor camps. A woman of sixty-five spent twenty-eight years of her life in eight different Chinese prisons. The fanatical Chinese attempted to destroy allegiance to Buddhism by burning the scriptures and forbidding spiritual practices. When prisoners showed, by slight movements of their lips, that they were attempting to say their prayers, they were severely beaten. Needless to say, the Chinese tried to substitute Mao Tse Tung's Little Red Book for Buddhism. Dr. Tenzin Choedrak, the Dalai Lama's personal physician, who himself was a prisoner for thirty years, triumphantly records that the inmates of one cell appeared to the guards to be studying Mao's writings assiduously. In reality they were saying a mantra for every letter in a line of the Little Red Book, and thus preserved both sanity and hope.

Much of what happened and still happens in prisons and camps is so far removed from civilized experience that ordinary people are incredulous. It took the Nuremberg trials to convince skeptics that the Nazi Final Solution of destroying European Jewry was a deliberately adopted policy. The conditions in the concentration camps of Nazi Germany were so appalling that merely reading about them is deeply distressing. The accounts of the tortures inflicted upon Tibetan monks and nuns are equally ghastly. How is it that anyone can survive such terrible experiences and remain intact as a human being?

One motive for survival is the desire to bear witness. Only those who have suffered know what it was really like. Victims feel that they must tell their stories, partly because doing so brings some relief; partly because they want to warn their fellows that fanatics are capable of cruelties which the ordinary person has never imagined. We know that some who best survived the Nazi concentration camps were those possessing an unshakable religious faith; for example, the Jehovah's Witnesses. Aristocrats who regarded their captors with contempt also had a better chance than most. The Tibetans who have told their deeply moving stories to Dr. Harrison regarded their Chinese torturers with compassion rather than contempt. They thought of them as misguided and ignorant rather than wicked, entrapped by the illusions of Communism, and thereby debarred from attaining enlightenment. As Dr. Harrison emphasizes, the most remarkable feature of these accounts is the absence of hatred or the wish for retaliation. Even when being tortured, these extraordinary people were praying for peace and reconciliation.

This wonderful tribute to human generosity and resilience will make many of those who read it wish that they could share the faith of these Tibetan Buddhists. Those who cannot do so will reflect that human beings are only capable of true nobility when they are dedicated to something greater than themselves. Nietzsche, who lost the Christian faith in which he was reared, refers to the artist's need for spiritual discipline, for what he calls protracted obedience in one direction: from out of that there always emerges and has always emerged in the long run something for the sake of which it is worthwhile to live on earth, for example, virtue, art, music, dance, reason, spirituality—something transfiguring, refined, mad and divine.[1]

Those who are only concerned with their personal needs and survival are, paradoxically, the least likely to survive. Those who serve a higher ideal than the personal may find that they are capable of feats of endurance which the average unbeliever can scarcely imagine. This book is both horrific and inspiring.

[1] Friedrich Nietzsche, (1886), *Beyond Good and Evil*, translated by R. J. Hollingdale (Harmondsworth: Penguin, 1973), p. 93.

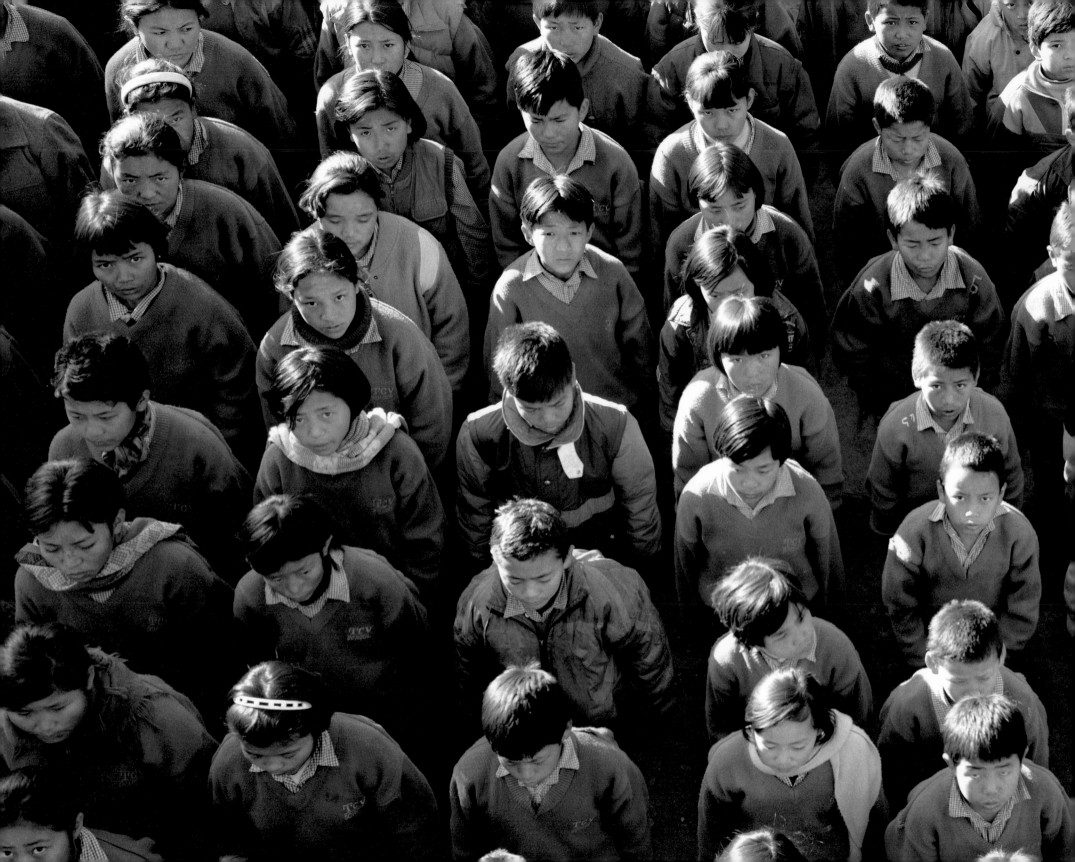

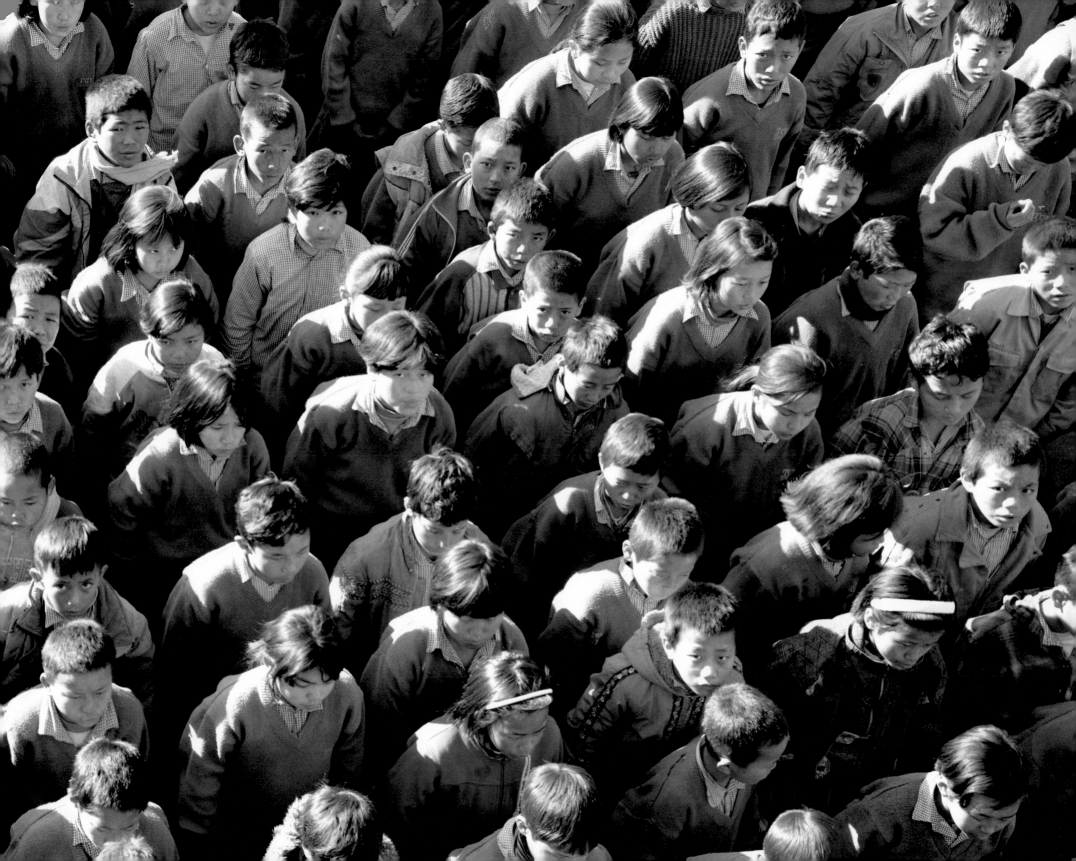

Essay by Vicki Goldberg

Tibet today is scattered far and wide. Since the Chinese invaded in 1950, many of the country's greatest cultural and religious artifacts have been removed to foreign lands to ensure their preservation, and much of the populace has gone into voluntary exile. Stephen R. Harrison went to India in search of Tibet.

The subjects in his photographs are Tibetans, the subtext exile and the refugee condition, which have put an unholy stamp upon our times. In western art, exile amounts to a twentieth century trope, most honored by photographers. Despite millions of refugees in the past, European painters were only interested in the religious archetypes: the expulsion from Eden and the Flight into Egypt. Secular versions in art are scarce before Napoleon's exile sparked some interest, but cameras, journals and wars in the early part of this century brought the subject crowding into the realm of representation. Today, images of refugees stream across our consciousness as the state of exile extends inexorably across the world, confounding rational planning and moral expectations.

As for Tibetans, their beauty, dignity, religious tenacity and refusal to despair in the face of what should be hopelessness has attracted a good deal of recent attention from photographers and filmmakers. Always, there is more to know. A faith that can produce adherents who pray for world peace during torture or endure brutality in prison for thirty years without ever experiencing a nightmare is almost beyond western comprehension.

Stephen Harrison took a panoramic camera of the so-called banquet type to India. This large, heavy camera, which takes 7 x 17 inch sheets of film, was named for its frequent use as a recorder of club and convention dinners. When printing, he uses the exacting platinum-palladium process, which provides a remarkably long range of tones and delicate sepia tints.

Panoramic photography has long been associated with landscapes and group portraiture—group portraits could be lucrative if every subject bought a picture—and here it finds its traditional niche in images like those of monastic dancers arrayed in endless rows. Individual portraits in this format are extremely rare outside this book; Lois Connor's photographs of Navajos are among the few recent examples.

In a way, a panoramic picture of an individual is a form contradicting a content. People who are important enough to have their portraits made by painters or photographers are usually thought important enough to pre-empt most of the available space. Photographers like Henri Cartier-Bresson, Arnold Newman, and tourists who want to prove their spouses have been to Notre Dame have experimented with reducing the physical grandeur but maintaining the importance of the subject, but not in panoramas. Harrison's single (or sometimes paired) figures remain central, often literally, but except for a few instances where the formal, geometric surround makes an aesthetic statement, they pose in unpretentious, undramatic settings that would not often claim so much attention. Nor are the images metaphorical, yet their very format emphasizes the isolation of people whose lives have been stripped of so many landmarks.

What is most extraordinary about these people is beyond the capacity of the camera to convey. Photographs of butter sculpture and monastic dancers contain enough information to pique curiosity but provide only the barest introduction to a culture. The portraits here are direct images of willing

subjects, made with sympathy and without artifice; in light of what we know, they become rather touching. Still, they do not, cannot, tell us enough. The subjects do not necessarily look like exceptional individuals (whatever those look like) but in fact they are, for their psyches and souls seem to be intact even if their bodies, families and futures are not. These pictures tell us something about the limitations of photography, which can neither reach beneath surfaces nor explain the unknown. Words are better: they can reveal facts concealed by appearances and fill in the histories behind silent faces and unreadable eyes. Stephen Harrison performs a real service in giving these people their voices, as they speak their own stories and tell their own lives.

The portraits themselves are merely the outward, daily-dress signs of courage, faith, pain and danger that many of us could scarcely imagine. Images that slip their moorings, they must be read at different levels: portraits of individuals; images of exile and, in their way, of faith; and emblems of patriotism, for several people agreed to be photographed in hopes of helping their country. How much help even the most sympathetic photographs can give is another matter, considering how little success the West has had dealing with China on human rights issues. But if Tibetans have not given up hope, how can we?

As a psychiatrist, Stephen Harrison has worked with people with every sort of problem, from mental illness to cancer, work he refers to as "the landscape tour of humanity." He has taken the tour once more, this time with a camera.

Unlawful Entry

He entered into my country without passport
or visa, with his honey-coated words.
My beloved grandparents,
so religious and innocent,
never dared to check
the evil inside the Chinese man.
They treated him with our tsampa and salt tea,
and after tasting our foods for a year,
the vampire or shameless red star
started transferring his blood to our country.

Sixteen-year-old Tibetan girl

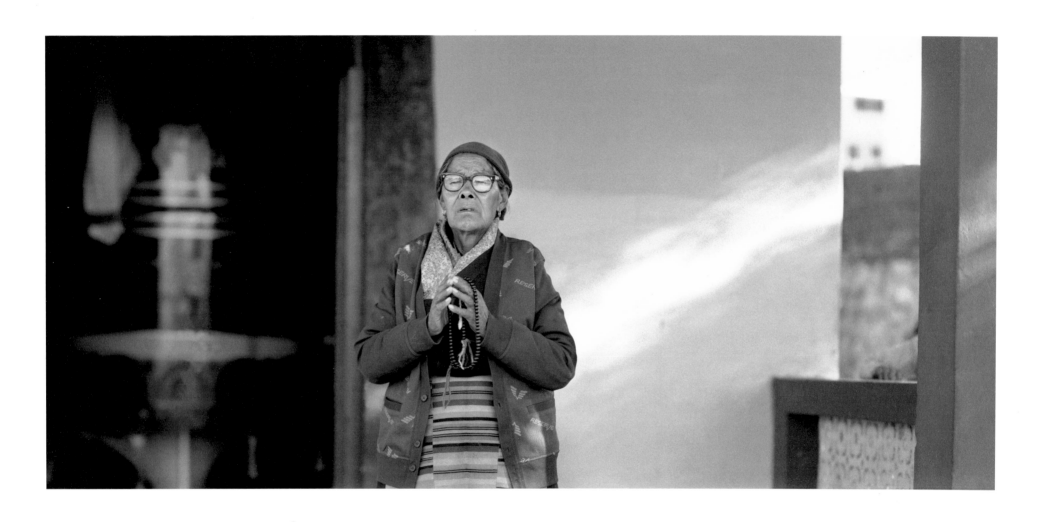

Woman Offering Prayers, Rajpur, India

THE WHISPER OF

INTRODUCTION

PRAYERS

I have always found the broad variety and diversity of our human race to be mysterious and fascinating. I suppose that is a major factor in why I eventually settled on psychiatry as a profession. We are all so uniquely different and yet at the same time so similar. The existence and complexity of the human mind is extraordinary.

A sage once said that the world is made up not of atoms but of stories. As a psychiatrist, I am allowed the privilege of bearing witness to these stories and helping their authors make some sense of them. I often find myself feeling rather small in the process, for I must confess that traumatic experiences have not been a frequent part of my life. Yet being a psychiatrist is wonderful in that it affords the unique opportunity to spend relatively long periods of time with so many different kinds of human beings on a deeply personal basis. By this I mean that I have the opportunity to engage in conversation with people about experiences that are highly personal and private. Because of sensitivity, these topics probably would not arise in usual social conversation. I must also admit that, in my work, I feel a bit like an explorer, but instead of exploring exotic lands, I am extended the privilege of visiting with the entire broad range of human beings and listening to the stories they bear.

As a professional, people usually do not come to my door because of success so much as pain and suffering, and I witness daily the effects of unforeseen traumas and tragedies. The good news is that, in spite of such catastrophes and sufferings, I have also witnessed the human spirit as being remarkably resilient. Not only does it endure, but ironically it often thrives under such adversity. It has been my experience that, in many cases, these tragedies end up enriching our lives in spite of our protestations. That this can happen at all is a bit surprising.

Although I am understandably somewhat desensitized from working with people who have been through traumatic experiences, I was not at all prepared for what I was to find in working with the Tibetans. I found eighteen-year-old nuns who had been raped, beaten and shocked with seven thousand volts from electric cattle prods. I found monks and nuns who had been suspended by their limbs and beaten for hours at a time. I found people who had been incarcerated and tortured over years and decades of time for no substantial reason. I found mothers and fathers bringing their children over nineteen-thousand-foot peaks in the middle of winter, only to leave them behind to be educated and probably never to see them again as the parents returned to their farms in Tibet. I found loss and tragedy everywhere. The stories were unending.

So were the steady stream of refugees. Winter and summer. Day and night. Mountains and plains. Their journeys were marked by starvation, subzero temperatures, severe snowfall, death from starvation, limb amputation from frostbite, retinal eye burns from snow blindness. By arrest and return to prison by the Chinese police. By repeated robbery in Nepal by the border partol. By arrest in India for being an illegal refugee. Again and again, the list goes on: rape, assault, imprisonment, forced abortion and sterilization; beatings and beatings and more beatings.

Like ships torn from their moorings by cyclone-like winds, Tibetans were scattered from their motherland to many parts of the world. Yet I found, in spite of the upheaval, many remarkable Tibetans who had graciously gone on with their lives. And with them, they brought their radiant lightheartedness, generosity, kindness and compassion. It was a sight that I would have normally not believed to be possible — how such severe trauma could be left so far behind and anger and hatred so minimal, how kindness can be a goal to be practiced intensely in daily life.

Numerous questions arose in my mind: How could so many people have been brutally tortured over so many years and yet not bear the deep psychological scars that I usually see in my work as a psychiatrist? How could mothers and fathers so joyfully surrender their children to the Tibetan schools in India, knowing they would most likely never see them again? How could an entire culture be so hungry for education, and where did this concept of education originate, since Tibet itself is a farming and nomadic culture? How could so many monks and nuns be severely tortured and yet harbor so little hatred and revenge? How could so many Tibetans who are just barely eking out an existence be so generous with their food and possessions? How was it that I never found a classic example of post-traumatic stress syndrome in my more than forty interviews, in spite of brutalities and sufferings that defy the human imagination? How could Dr. Tenzin Choedrak, to name just one person, in his more than thirty years of torture in Chinese prisons, never have had one single nightmare? That this could possibly happen defies any simplistic explanation and must again lead us back to the ultimate wonder of our human underpinnings.

The title, *Whispered Prayers*, originated from the many conversations I had with Tibetans who were imprisoned and severely punished by Chinese guards for uttering their prayers. But to stop these prayers proved impossible. Whether torture, beatings or duct tape was used to extinguish their vocalizations, the Tibetans, with their insatiable spiritual thirst, continued their prayers with an even greater intensity in the form of whispered voices or, when that failed, silently in their minds. Tens of thousands of prayers uttered daily tethered their minds not to hatred and revenge but to compassion and understanding. *Whispered Prayers* speaks to the indestructible strength and the unyielding volitional power of the human spirit. It speaks to the ability to take an active role in the creation of human compassion, courage and happiness.

My personal passage to India and my Tibetan project began in February of 1996. By nature I am not a political person and I knew almost nothing about Tibet, or China for that matter, when I first became involved with this undertaking. I did not know, for example, that the Chinese government had initiated a series of invasions of Tibet in 1950 that, within the next decade, would result in the occupation of the whole of Tibet and the eventual death of over 1.2 million Tibetans — about one-sixth of the total population — due to political persecution, imprisonment, torture and famine. I was not aware of the destruction of seventy percent of the rich forest reserves, the massive dumping of nuclear wastes, and the dynamiting of all but a handful of the six

thousand monasteries that before 1950 had dotted the Tibetan landscape. Nor did I know that over one hundred thirty thousand Tibetan refugees had fled their motherland since those days. Rather, these numbers were all too enormous and abstract to be meaningful to me, and I did not realize their significance in terms of the staggering weight of human suffering.

I journeyed to India as a photographer. Being a bit of an adventurer, I also wanted to immerse myself in a culture totally different from my own. That longing, coupled with a background in Buddhist psychology and Sanskrit, piqued my interest in Tibetan culture. I departed for India with my 7 x 17 inch Canham large format camera, four hundred sheets of film, ten film holders and five large cumbersome cases of equipment, which stack to a height of five feet and weigh in at four hundred pounds. I went alone. I had no itinerary and few plans of what I wanted to accomplish.

It was during the flight to New Delhi that I remember sheepishly confiding to the Indian man sitting next to me that I was going to India on a photography project. I was looking for reassurance, of course. He asked me if I had been there before and I replied that I had not. When he rolled his eyes and glanced at his wife with an evasive smile, I knew I was in trouble. The truth is that I was absolutely terrified. Here I was on the other side of the globe with four hundred pounds of gear and I had no idea of what lay in store for me or how I would survive. Thus I began my journey in fear and dread.

Weeks passed and my initial apprehension turned to excitement. I went through a honeymoon phase. Everything was so remarkably different from my normal life. I lost my usual sense of privacy because I had no automobile to separate me from my surroundings. I was never alone. I loved the generosity and sense of community. I felt a new sense of competency — like a child who has just learned to walk.

It was exciting because it was another world. To this day, I am left with vivid memories of being in the dead of winter with crowds of nomads and farmers all huddled together, each with their indoor fires, musty bags of clothing and the dense clouds of smoke and incense; hundreds of bodies were clothed in garments of another time, with faces blackened by their journey. It was as if I were seeing the Ellis Island of the past, and here I was allowed the great privilege of stepping back in time and visiting in the midst of our ancestors as if in a vivid dream. There was the delight of smells long since banned in more developed western countries: the odor of sheep, of incense and burning dung, and the odor of the mildew that coated the interior walls left from the monsoon season. And there were the ever-present sounds of drums and chants and roosters and horns and bells and barking dogs, and the sounds of the gossip as villagers filled their water buckets beneath my window in the early hours of the morning. There was nothing sterile about it at all. Western life had not yet sanitized this inner sanctum.

But I am getting ahead of myself. My journey began at the Tibetan Homes School, which is a large school of fifteen hundred refugee children, in Mussoorie, India. When the Fourteenth Dalai Lama and the Tibetans fled Tibet after the Chinese invasion, they traveled to India and settled in the

foothills of the Himalayas. They initially arrived in Mussoorie, which is one of the old British hill stations that lie at an altitude of six thousand feet. Thus it was fitting that my journey began there. Three weeks later, I departed for Dharamsala, India, where the Tibetan Government in Exile is located. I remained there for seven weeks before returning to the U.S. In November of 1996, I returned again to both of those locations for an additional seven weeks and then on to various Tibetan settlements scattered throughout India. In 1997 I made a third trip to India for four weeks.

Most of the subjects in this presentation were interviewed with the assistance of a translator. Artistic license has been taken to put these interviews in meaningful form. Because of the sensitivity of the information presented as well as the attitude of the Chinese government, the identity of the subjects has been protected as much as possible. In many cases, the names and locations have been deliberately changed. One sixteen-year-old boy who fled Tibet at age twelve stated this problem well when he said, "I tell this story for my country, but I request that you change all names and all dates. My parents have been very kind to me and I wouldn't want them to suffer."

S.R.H.

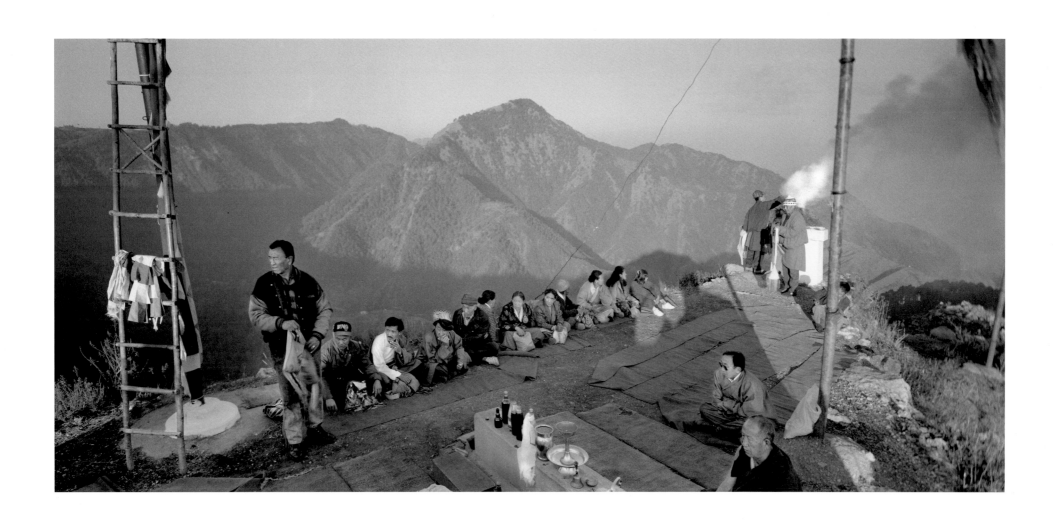

Preparing for the Tibetan New Year, Mussoorie, India

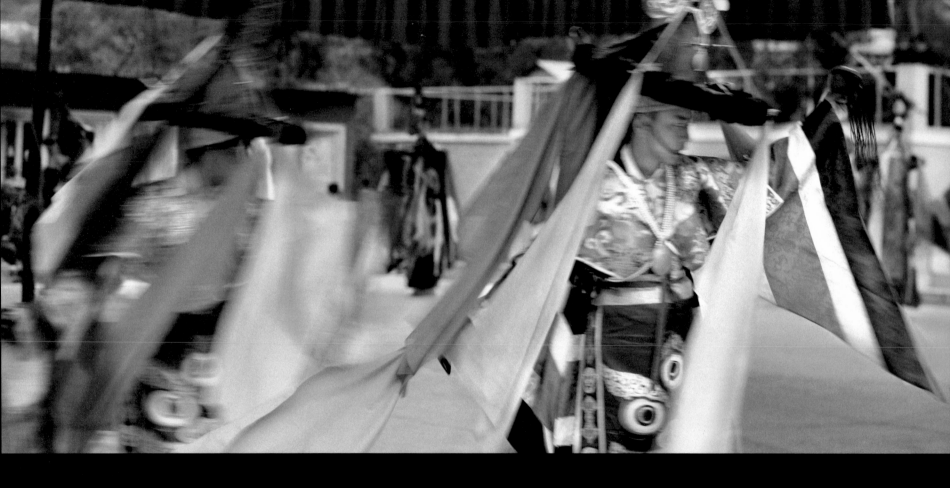

Monastic Dance I

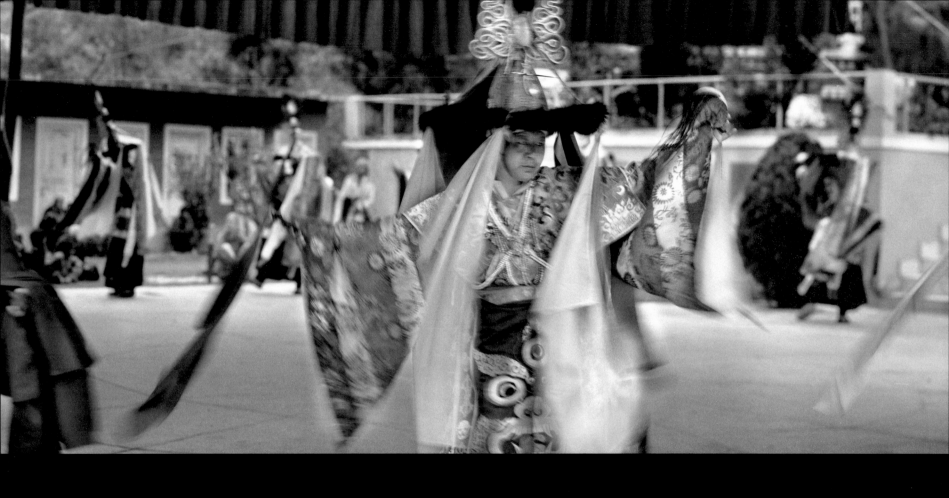

Monastic Dance II

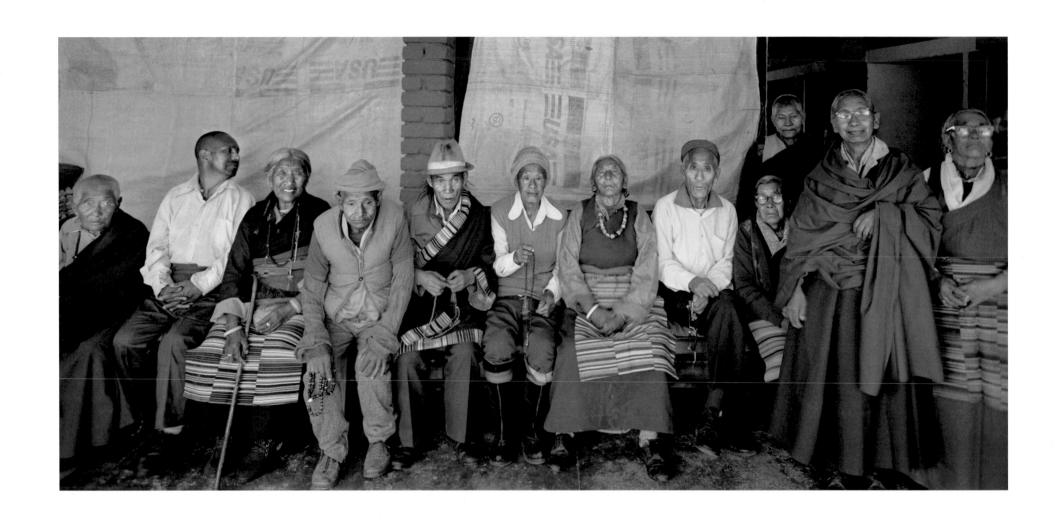

Old People I, Mussoorie, India

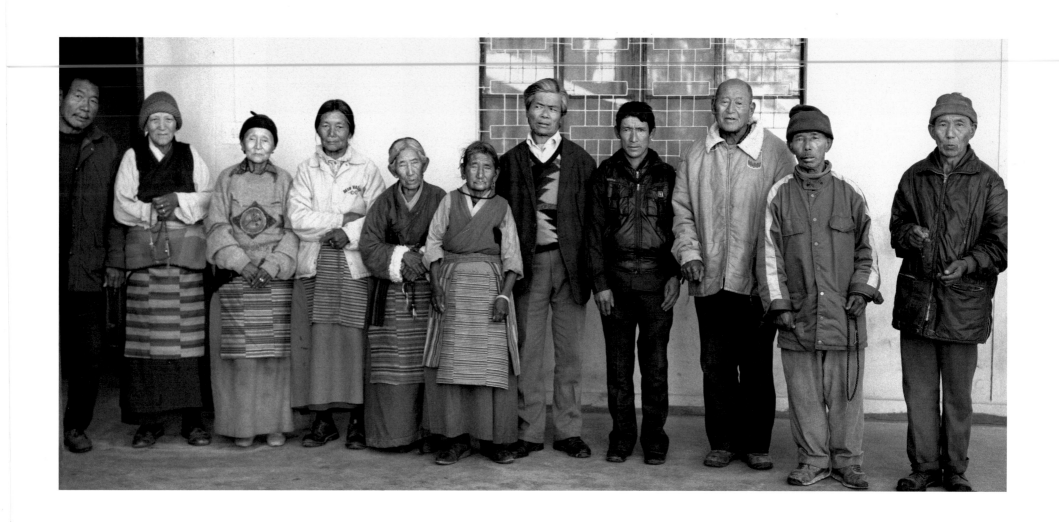

Old People II, Mussoorie, India

THE LAND OF THE

O ver one hundred thirty thousand Tibetans have fled over the Himalayas into India since 1950. They come for the simple reason that the human spirit does not fare well living under the unjust and arbitrary use of force. Tyranny is always deadening and suffocating.

For me, in years past, the word "oppression" had a hollow ring to it, mainly because it did not refer to any direct experience I have had. It did not strike terror in my heart, for I have never had to live under an oppressive government. I have not had to choose my words carefully either in my home or out of my home. I have been free to voice my disagreement of my government's political policies at any time. My father and mother have not been imprisoned for political activities and my family has not been fragmented. I was not beaten in school and my family was not taxed beyond their resources.

OPPRESSED As a child, I was encouraged to disagree and to speak my mind. I have always been able to read what I wished, and my educational background is full and well rounded. I have had no personal friends or acquaintances who have been incarcerated, tortured or imprisoned. I have known no refugees in person, and until my trip to India, I had never given the concept of refugee or political asylum any serious thought. The words "freedom," "repression" and "oppression" have always had a feeling of unreality precisely because I never had any actual experience with these conditions. My thoughts on human rights had always been based on intellectual knowledge and were therefore removed from reality.

Tibetans do not talk about tragedy and loss, because it is considered egotistical to complain. In Tibetan culture, suffering, which is implicit in life, is to be borne with dignity. Thus, one would never know of these brutalities by judging from the radiance of a Tibetan's being. Yet thousands of monks, nuns and elders have served decades locked away in Chinese prisons and have endured living nightmares beyond the farthest stretches of the human imagination. It was another world, and I often had to remind myself that this was not a bad dream and that I was actually hearing these stories. Virtually every Tibetan had a harrowing tale to tell that would put even the wildest Hollywood adventure film to shame. I began to awaken to the darker side of human nature and to the agonies that human beings can inflict on their fellow beings. The words "oppression" and "human rights" began to take on real meaning.

The alleged political crimes of injustice — the mere possession of a photograph of the Dalai Lama, the raising of a Tibetan flag, carrying a placard, the chanting of "Free Tibet" or "Chinese, Go Home" — were all simple actions that in the United States would have amounted to insignificance. And yet, in occupied Tibet, they were cause for the worst retaliation. Participation in a demonstration that was entirely peaceful was an even worse offense.

"I will never forget the demonstration that I saw when I was a young boy in school before I left Tibet. You see, in our village the school was near the police building and the main monastery. One morning, some of the monks began to demonstrate against the Chinese. When the demonstration started, our teachers closed the school. We were all trapped inside and could not leave safely, so we stayed there waiting for it to be over. Some of us hid and peeked out of the windows of the school. We saw the Chinese

shooting Tibetans. We saw them use electric batons to beat and prod the people. Tear gas smoke hung in the air, and Tibetans were running everywhere to get away from the police. Many people tripped and fell to the ground. Dead bodies were all around and the air was filled with terrible screams and crying. It was like the worst nightmare I have ever had in my life. I kept staring out of the window unable to believe what I was seeing. I will never forget this scene until I die." (15-year-old boy)

But there are many other forms of oppression that are far more subtle than these and less shocking to the eye. There is the pervasive lack of educational opportunities due to taxation, or the question of what version of education is acceptable and taught, as described by a young Tibetan refugee.

"In Chinese schools I learned a very different version of our world history than what I know is the truth. The teachers told us that Tibet has been a part of China for hundreds of years. In one of my political classes, one of the questions on a test asked whether the Dalai Lama had received the Nobel Peace Prize. The four possible responses were: A - Disagree; B - Agree; C - Reject; D - Uncertain. Of course, the Chinese teacher wanted us to choose "Reject." I knew the truth was B, but if I chose "Agree," then I would not receive my test scores and my education would come to a halt. This was when I truly realized that all Chinese education is controlled by the Communist Party. We were taught that communism is like the sun rising in the eastern sky. We were made to sing many communist songs about the greatness of communism, and how prosperous the conditions are under communist rule. The Chinese communist philosophy was everywhere. It was in the history, the science, the mathematics, the geography; there was no escape from it. The Chinese are trying to brainwash us and their goal is to create a people who have forgotten who they are." (24-year-old Tibetan)

Free speech is taken for granted in western countries and it is difficult to imagine life without it. Yet its absence and the absence of education and opportunity make for a gray life without color.

"It was one year ago that I decided to leave my family and Tibet. We have a very uncomfortable life there. We are taxed very heavily by the Chinese. There is only one school in my village and it is a Chinese school. It is very expensive. People in my village can never afford education, nor can I. I am not educated and have never been so. We are not allowed to speak or think freely, and I must be careful what I say. I often feel trapped inside myself, as if my thoughts cannot move or a heavy blanket has been placed over my mind and heart. It is an empty feeling and I am unhappy all the time." (Tibetan nomad)

Oppression, of course, is nothing new. Genocide and ethnic cleansing are well documented throughout the millennia and the development of my own country as well. Unfortunately, the ability of human beings to repress and punish those perceived as different has a long history and is deeply rooted in the human mind.

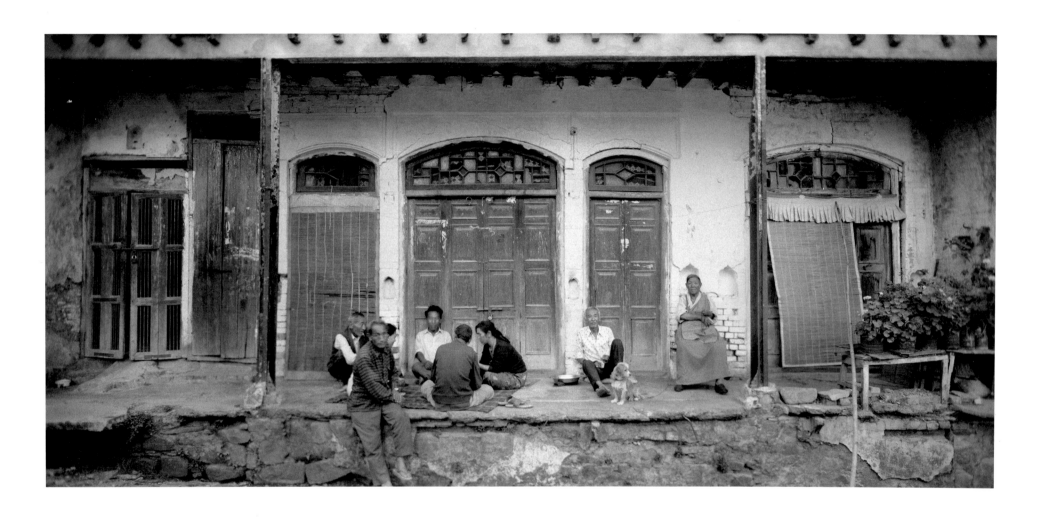

Card Playing

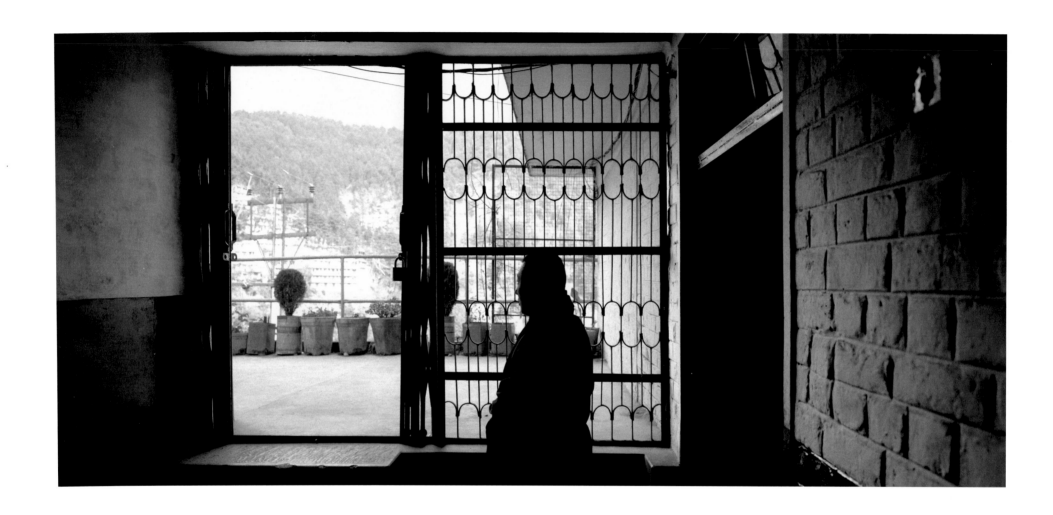

THE ANONYMOUS MONK

I wish to remain nameless because I plan to return to Tibet, and my life and that of my family will be in danger if I speak these words and am later recognized. Religious persecution is intensifying in Tibet. The Chinese officials have recently authored and published four books of approximately two hundred pages each that are specially designed for the monks in Tibetan monasteries. Every monk is obliged to study these texts, which are all written from the Chinese viewpoint.

The first text is about the historical background of Tibet. The second concerns the revised legal history of Tibet. The third book is about Buddhism and religious policy in Tibet, and the fourth is on the general conditions in Tibet.

After the monks have studied this material, they must take a test to prove their understanding of it. If they fail the test, they can be expelled from the monastery irrespective of age. If they make passing marks, they must then make a pledge proclaiming their loyalty to the Communist Party. They must publicly criticize the Dalai Lama and the Tibetan Government in Exile. The last requirement involves the second highest spiritual leader of Tibet, the Panchen Lama. All monks in the monasteries are required to pledge their support in favor of the Panchen Lama who was selected by the Chinese government and denounce the Panchen Lama selected by the Dalai Lama.

The monasteries in Tibet are now nothing more than tourist attractions. There is no real spiritual life taking place within the walls of these great temples. All pictures of the Dalai Lama are strictly forbidden. Most scriptures and books were burned long ago, and the few teachers who remain are closely monitored by the Chinese police. Religious freedom has virtually been destroyed, as the monks are not even allowed to do their own spiritual practices without permission from the police. The lamas and tulkus have been forced to marry. Because of these regulations, it is impossible and impractical for the monks to study Buddhist philosophy. Inasmuch as the primary goal of monastic life can no longer be met, many of us are leaving our beloved homeland.

Two Monks Who Fled

We became monks at a very young age because we had ideals and wanted to contribute to the good of humanity. Our goals changed over the next decade, however, as the many restrictions and regulations of Chinese surveillance made genuine spiritual practice impossible. Consequently, we took part in peaceful demonstrations against religious repression in Tibet and were incarcerated in the same prison on two different occasions.

During our first imprisonment in 1987, for the crime of shouting pro-Tibetan slogans, we were made to walk long distances, for eight hours at a time, with no stopping. This was enforced under the watchful eyes of Chinese guards, and if one of us fell down, they would apply electric shock or kick us to make us walk again. All this walking damaged our legs; many times we were unable to move our feet without the assistance of walking sticks. These practices and others are used as a form of torture because they leave no scars and thus cannot be detected by human rights groups.

It was unthinkable for us to give up our commitment to furthering the survival of Tibetan traditions. So after our release from prison in 1988, we continued to work against religious oppression in minor political activities. We were arrested for the second time in 1989 and charged with disclosing national secrets and organizing an underground committee. We were imprisoned for six years and subjected to torture and solitary confinement. Upon our final release from prison, we were banned from monastic life and all work in Tibet, so we fled to India.

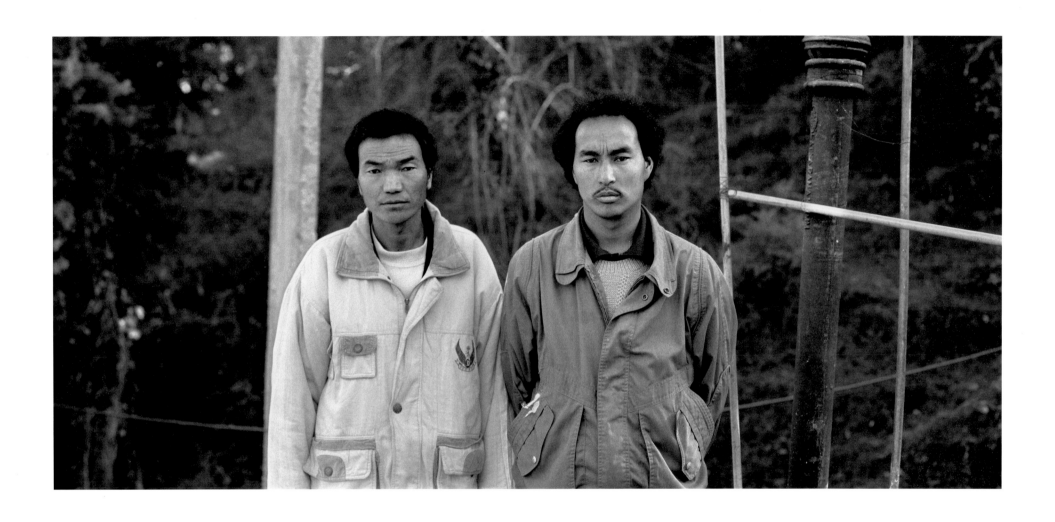

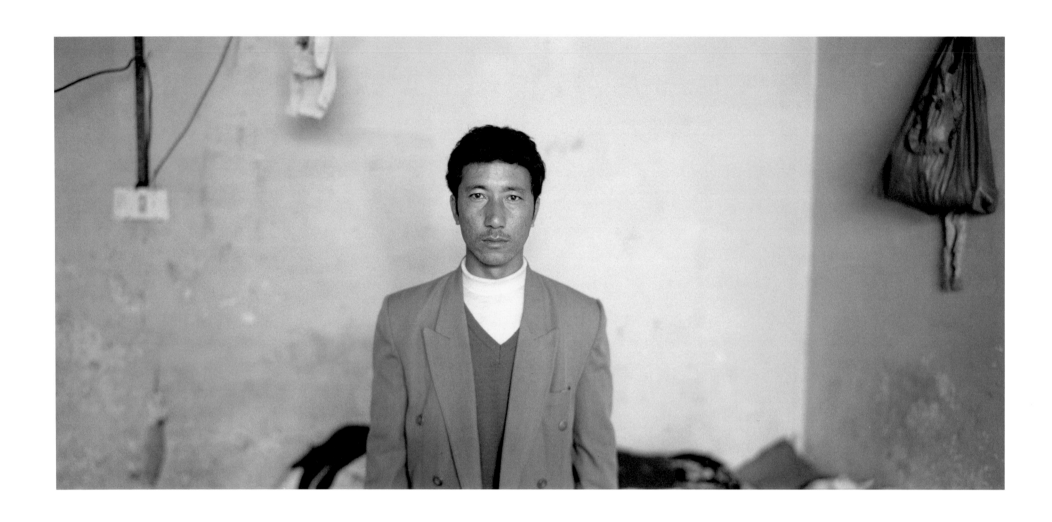

THE MAN WHO MADE POSTERS

As a young boy in Tibet, I was trained in the film industry by the Chinese. By the time I turned twenty-seven, I was a successful man. I had my own house and an automobile. I worked for the police as a photographer, and my job was to photograph both Tibetan and Chinese people who were alleged criminals. My photographs were used to convict them. Eventually, I began to notice discrepancies and contradictions in the actions of the Chinese authorities. I began to feel increasingly uncomfortable in my role as photographer. I saw people who had done nothing wrong being harmed and even killed. I realized that the Tibetan people were receiving propaganda and false promises. I discovered that the Chinese were telling lies about their intentions, and I felt it was my duty to tell the Tibetan people the truth.

So it was that over the next several years, six of my friends and I created thousands of posters and distributed them at night. These posters were handwritten and emblazoned with slogans such as "Stop Forcing Abortions on Tibetan Women," "Chinese Are Violating Human Rights in Tibet" and "Free Tibet." I placed the last of our posters on the police station door. They read, "Chinese, Go Home!"

The police traced my handwriting and I was arrested. I took all the blame in order to protect my friends. I went from being a successful young man to one surviving like an animal. I was subjected to eight months of severe torture. I was repeatedly shocked with electric currents and cattle prods, punished in ice rooms, beaten with clubs and hung from the ceiling so that my feet would not touch the floor. I was strapped on wheels with electric currents passing through my body. I was burned with cigarette butts and chained to walls and hooks. I lost consciousness repeatedly.

During the beatings I received in prison, I would pray, "May Tibet be free." I knew that the Dalai Lama wants a nonviolent solution to the problem of the Chinese occupation of Tibet. So I accepted that I would be harmed, but for a worthy cause. It was important that I saw my tormentors as people who, like myself, were injured. I took the attitude that they could do whatever they wanted to my physical body, but my mind was free to think for itself. I concentrated my mind on His Holiness so intensely that as I was being tortured, I could actually feel his presence. So I did not feel the pain. I did not pray for myself, but I did pray for peace for all beings. The Tibetans believe that the body is not so important but that the mind and soul are essential. What is important is where your mind is. So I practiced this every minute of every day. I was released from prison in 1995 after serving four years.

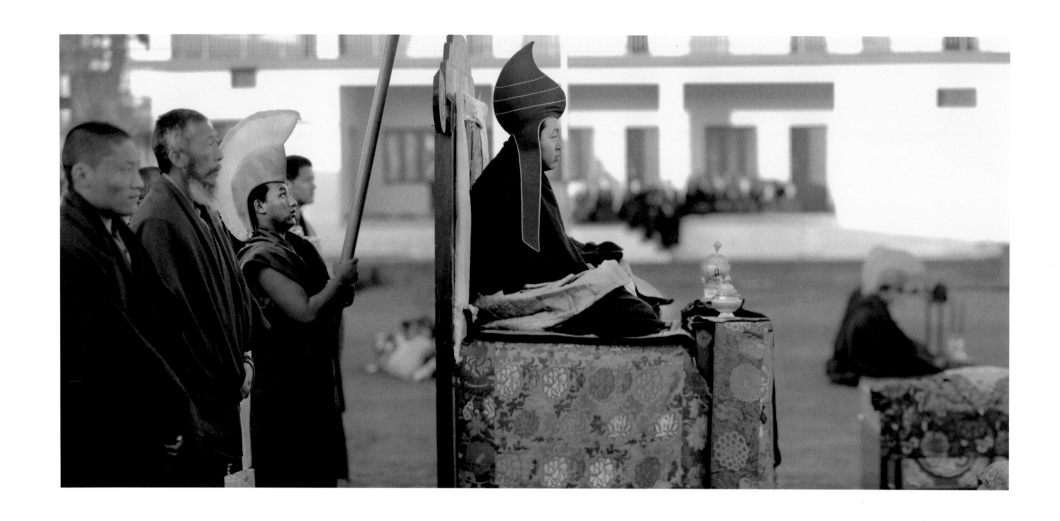

Religious Ceremony I, Clementown, India

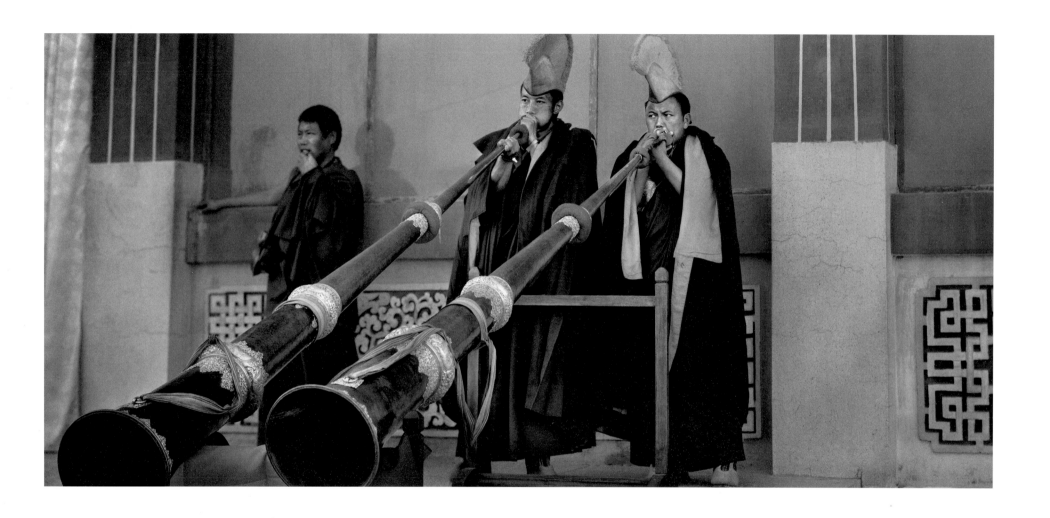

Religious Ceremony II, Clementown, India

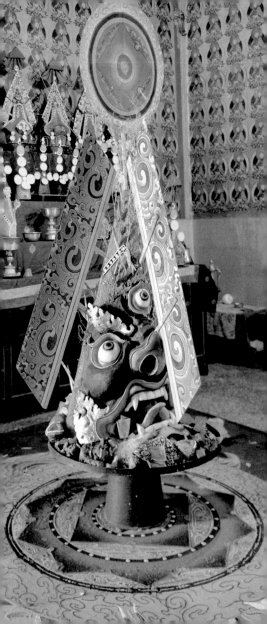

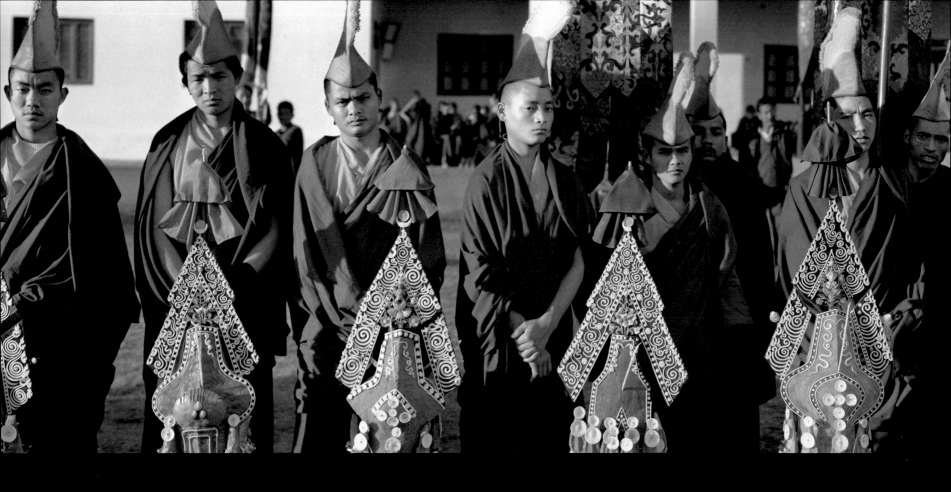

Monks with Butter Sculptures, Clementown, India

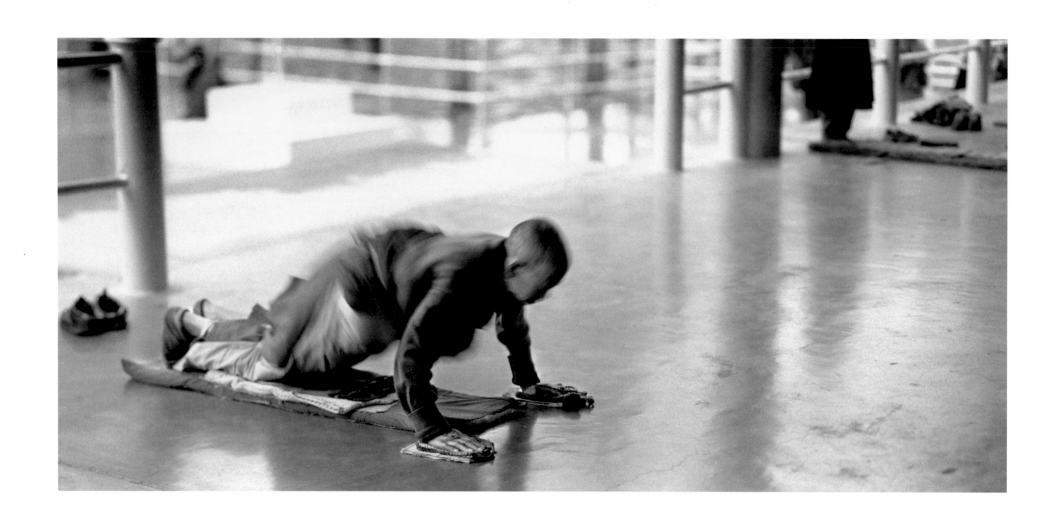

Prostrations, Dharamsala, India

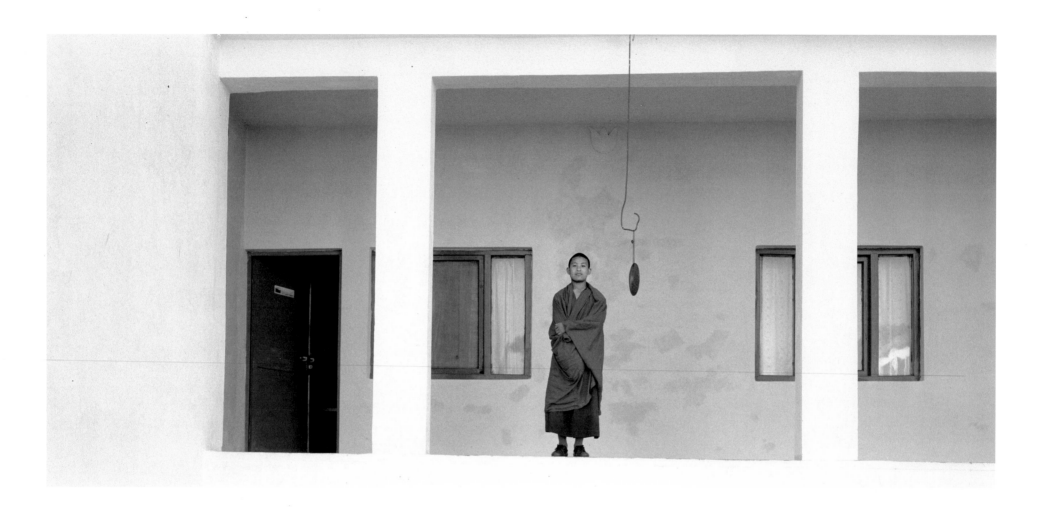

Boy Monk, Clementown, India

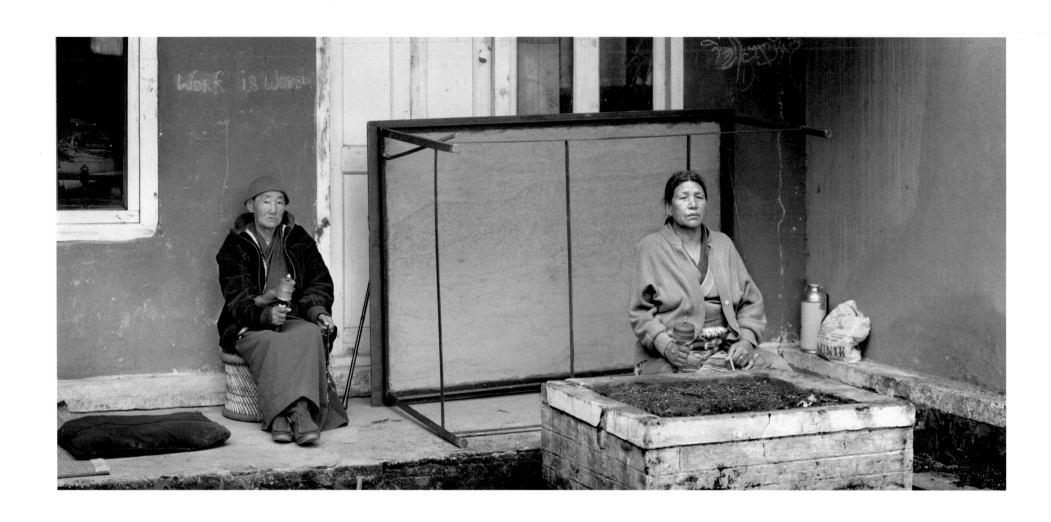

Women Sending Prayers and Blessings

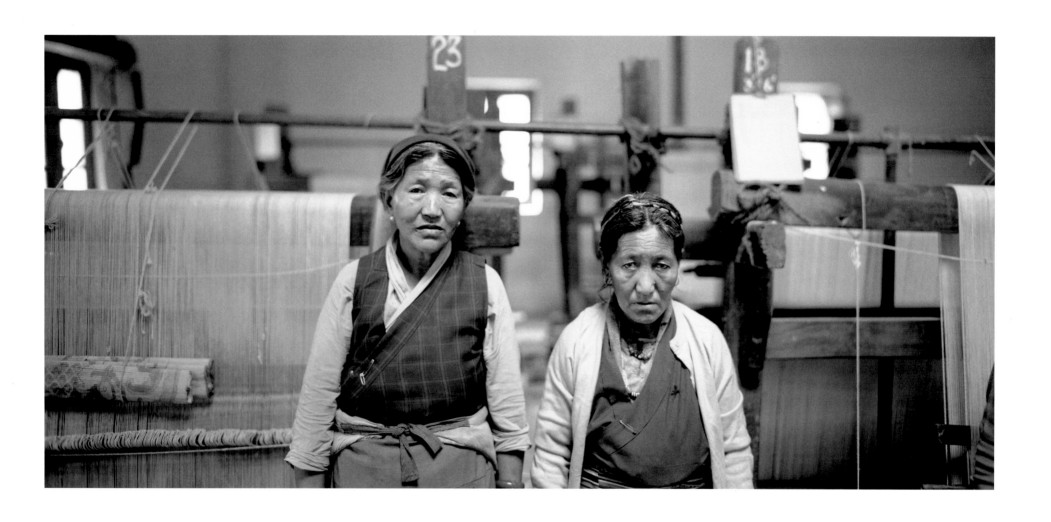

Carpet Weavers, Dharamsala, India

THE FAMILY THAT WAS TAXED TO DEATH

I am standing in this photograph with my young refugee friend who, like most children, left his parents behind in Tibet. I myself come from a large family with eight brothers and sisters. In the past, we were a wealthy family and had over one hundred acres to farm. Then the Chinese came and took away our family land for what they called redistribution. We were reissued only twelve of our original one hundred acres because, by Chinese policy, the amount for redistribution was to be based solely on the number of adults living in our home and did not include the children. When our situation changed and we children became adults, we were not issued any more land. The twelve acres could not possibly support us as a family and we were barely able to survive. This happened to many Tibetan families.

To this day, the Chinese demand much in taxes and take the best quality of barley and wheat to be paid as taxes to the state. Everything is taxed, including education, and my family could not afford to send me to school because of the school taxes. Even the teachers require special gifts from the family. On one occasion, I remember a neighbor telling the Chinese officials who came to collect the taxes that he did not have good quality barley and wheat because his land was so infertile. The Chinese police came and accused him of holding back the best barley and wheat. They took him out in front of all the villagers and shot him as an example of what happens when the best barley is withheld. I will never forget this.

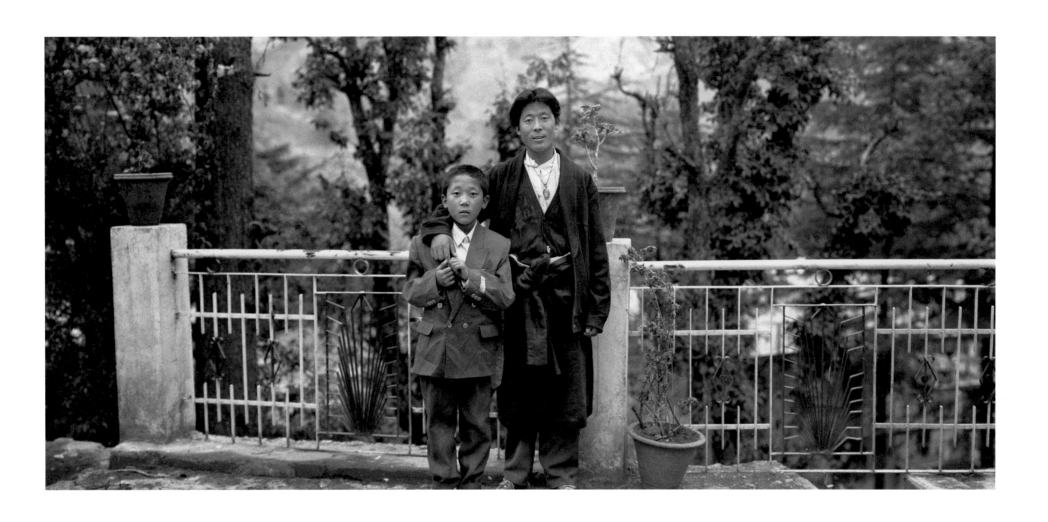

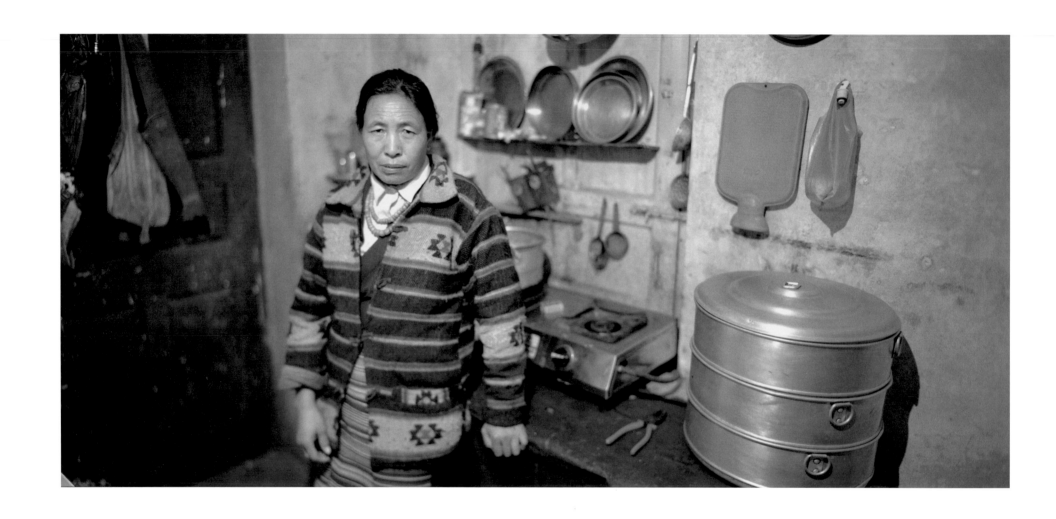

The Saddest Day of My Life

I was thirty-five years old and living in the Amdo region of Tibet when the Chinese police first came to my house. It was an ill-fated day. I had three sons and I was pregnant with a fourth child. In my village, every woman who has two children must be sterilized, for it is Chinese policy to do this. Nearly all the young women in my village were already sterilized. If a woman who is not sterilized should become pregnant and she already has two children, she is forced to have an abortion, regardless of the status of her pregnancy. In addition, the Chinese government demands a tax for every child that is born. If we do not have the money to pay the tax, they will take part of our land away from us as payment. They told me I would have to pay the tax if I bore my child, in essence trying to force me to get the abortion.

In Tibetan Buddhism, it is a sin to get an abortion, so I begged the police not to make me abort my child. Sadly, I told them that after my child was born they could sterilize me. My fourth child was thus born, and when he was eight months old, the police again came to my home to take their due, to force me to become sterilized.

My husband and I walked many days to the hospital because there are no hospitals near our village. I cried a great deal. I saw many young women there at the hospital, also waiting to be sterilized, and they were crying too. I lay on the bed and was given an anesthesia injection. Because it really didn't work very well, I was awake and saw what the three Chinese doctors did to me. We had to pay for the sterilization and all the expenses. Eleven women were sterilized that day and there was one forced abortion.

When our child turned one year old, we were asked to pay the tax for him. As we are very poor, we were not able to pay it. I had no energy to work in the fields and my children were all young and were unable to help me. Eventually, we had to move. To this day I have bad dreams about the sterilization.

The Gift That Created Suffering

In 1994, my family and I were on a pilgrimage in Shigatse and we stopped at the Tashilhunpo monastery. There were many American tourists present. I walked up to one of them to inquire about the Dalai Lama. I did not speak English and there was nobody to translate, so communication was difficult. The Americans videotaped me and asked many questions about Tibet. Finally, one tourist reached into his pocket and graciously handed me five hundred pictures of His Holiness. Photographs of the Dalai Lama are forbidden in Tibet and the police are always searching for more to destroy. It was not long before many people came to learn that I had photos of the Dalai Lama. One by one, I gave the photos away on my return to my home town in the province of Amdo. News of the photos traveled all over the village and Tibetans everywhere sought me out.

One day, eight Chinese policemen surrounded me and said they had many questions to ask. They brought me to the police station and demanded to know what I had done. I admitted that I had given away many pictures of His Holiness, but I denied that I had been interviewed by American tourists. They started to kick me like I was a football. They used a special finger cuff and locked my thumbs together. When I fell down, they pulled me up by my fingers. They continued their torture for the next five days, beating me three times a day for two hours at a time. Over and over they asked me the same questions. After five days, they finally gave up on me and let me go.

I came to India to tell the world what the Chinese are doing to Tibet. I feel it is my duty to provide this information so that my country will not become a place that time forgets.

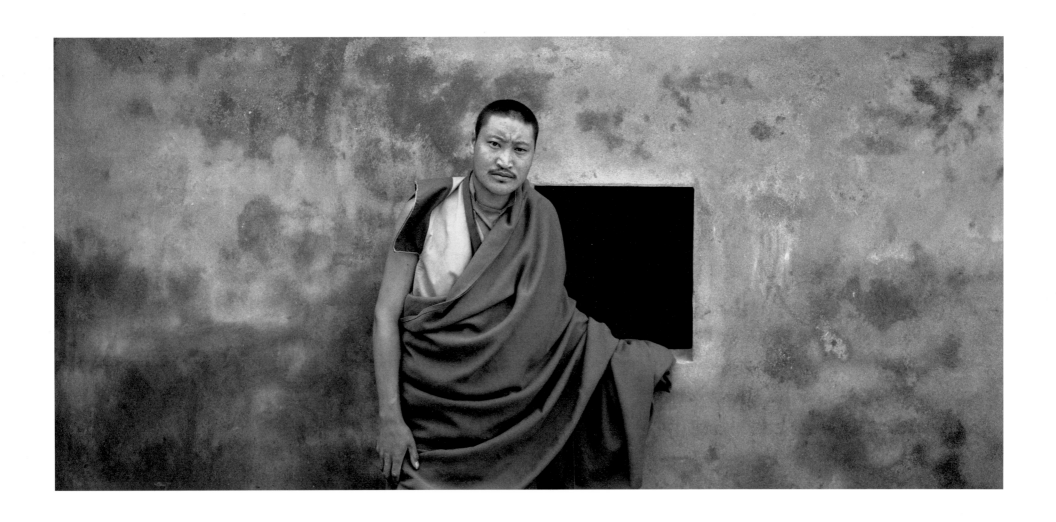

THE JOURNEY TO

The escape to India is a dangerous journey, requiring many months to complete through the snow-covered mountains of the Himalayas. There, on the run, Tibetans fleeing from China and its police endure snowstorms, blizzards and raging rivers filled with ice. They make their way over snow-clad peaks where the snow is up to the height of their necks. Children and elders, young and old, the infirm and the disabled, nomads and farmers, monks and nuns—the flow of refugees is constant. And they're not just Tibetans, but Chinese peasants as well. It seems that nothing will stop these seekers of freedom from arriving even though the personal perils are many.

First comes the task of raising the necessary funds to hire a guide. The guide's fee varies from fifty to one hundred dollars, payable before the journey begins. It may take months or even years of hard, difficult labor to make the payment. Selecting the right guide is a critical life-and-death choice. Many Tibetans have been cheated in mid-journey by ruthless guides who abandoned them in the dark of night. If the guide is inexperienced, groups of Tibetans risk being hopelessly lost in the Himalayas.

The journey requires, at the least, thirty days of climbing and walking over high peaks. Ninety days is not unusual. The only food available must be carried with the individual Tibetans and consists of tsampa, a fried barley flour. Then there is the unpredictable weather and inadequate clothing. The elements are so unforgiving that even a single day of disorientation in the Himalayas can mean the difference between survival and dying. Groups as large as one hundred have been known to perish in snowstorms along the way. Starvation, illness, pneumonia, hypothermia and drowning are frequent causes of death.

The rivers in winter are clogged with ice and snow. There is no way to cross them other than to remove one's clothing and carry it high above one's head in plastic bags, forming long human chains of refugees inching their way across the treacherous waters. In the spring, the problem is with the increased surveillance by the Chinese police and the more dangerous water runoff from the melting winter snows, making the river crossings even more precarious.

The Tibetan border is heavily patrolled by armed soldiers at numerous checkpoints and bridges, so there is always the very real possibility of arrest and imprisonment by the Chinese police. To be captured trying to escape from Tibet risks imprisonment and possibly torture. If the refugees are fortunate enough to flee into Nepal without detection and capture, there is the possibility of robbery at the many border checkpoints there. When life is harsh, it brings out not only the best but the worst in humanity, and the border areas are rumored to be known for their corruption and abuses. These Nepalese outposts, being remote and isolated, are not supervised, and the soldiers and police are numerous. On being discovered, young and old alike have described being robbed, and not just once but usually several times as the various checkpoints are crossed. The final ten-day leg of the long journey is usually made by begging for food, as all the rations have been plundered and nothing remains.

And then, as if that isn't enough, on their arrival in India the Tibetans are greeted with the overwhelming difficulties of adjusting to life in India as illegal refugees, where work opportunities are minimal. Here they live without the support of their families, their only security being dreams and memories. They can be arrested in India, for they are there illegally — existing without passports. They have lost their country and have no place to call home.

Why then do men, women and children make this harrowing journey from nowhere to nowhere in spite of such poor odds? They do so for the sake of escaping the far worse fate of having to live in a strangled and occupied country that has been stripped of its soul. Their journey is a tribute to the human spirit and a protest against the indignation and horrors that humanity in its blindness and ignorance has always, from time immemorial, imposed on its kindred human beings. It is a statement to that unyielding power that lies within each and every one of us who is able to speak up and take action. This journey is the search for a more satisfying life and a refusal to accept less. It is the quest for one's dreams and ambitions and a step toward more freedom and more choices. This is the ultimate journey that not just the Tibetans but we all must make in one way or another in our personal lives. The mountains are tall and the path is fraught with unknown dangers. To undertake such a journey at all requires great courage and determination.

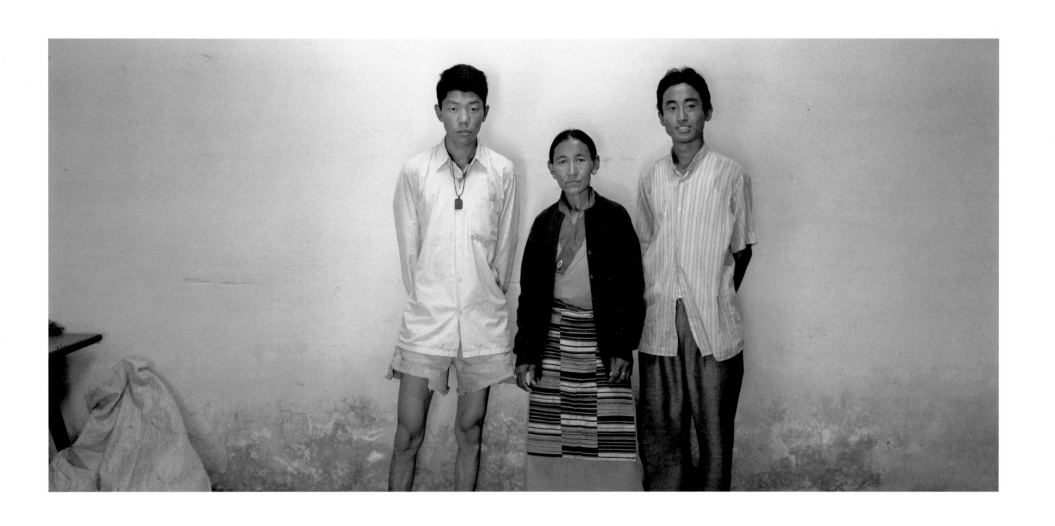

Carpet Trimmers, Tibetan Settlement

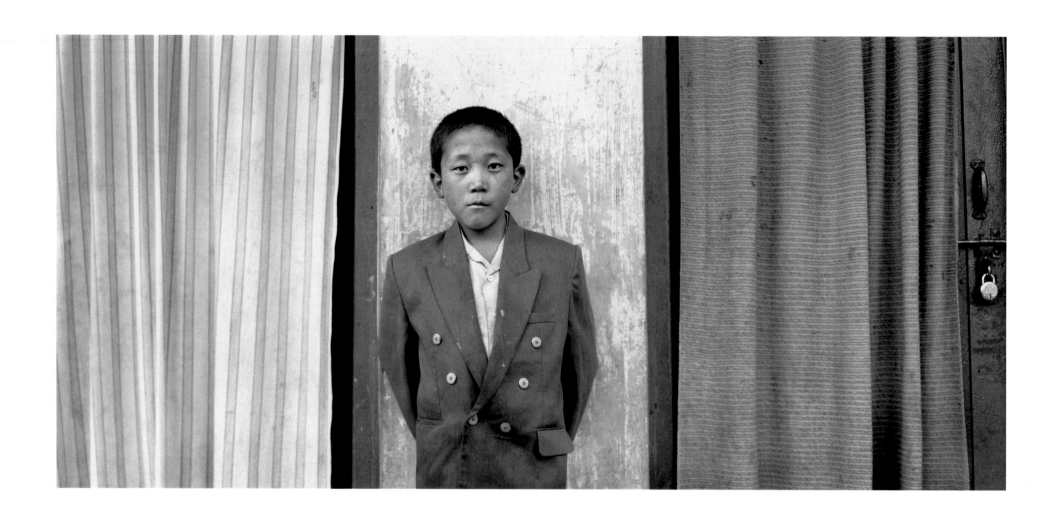

The Boy in a Suit

I am ten years old, from Tibet. I have just arrived in India and I am dressed in the clothes I wore over the snowy mountains. My mother paid a guide to help me escape to India. I said good-bye to her and she returned to our village. There were twelve adults and four children in our group. I began to cry on the first day of our journey, and the guide told me to be quiet or I would bring them bad luck. Our trip over the mountains was treacherous. We hit snow up to our chests. We were able to sleep for only a few minutes at a time. The snow became so deep that we could no longer walk, so we found a cave and stayed there until it stopped snowing. Days passed. There was no food to eat or water to drink, and it was so cold that we could not even speak. The guide thought for sure that the four of us children would die because we were starving from not having any food to eat for so long. Dressed as a beggar, our brave guide went down to a small village in the falling snow to beg for food. As we watched him descend, we could see Chinese troops below with their long guns drawn. Eventually, he returned with some fat, powdered barley and matches, which he had begged from the villagers.

Every night, the guide let me sleep next to him in the cave. Four days later, we felt better and continued on our way, only to be robbed by border patrol at each of the four Nepalese checkpoints that we crossed, until we had nothing left. All the money my mother gave me was gone. We begged for food as we walked the last ten days of our journey. Finally, we arrived in Kathmandu. One of the other children had to have his feet amputated at the hospital there because of frostbite. I am now at the reception center in Dharamsala. The day that this photograph was taken was the first time I cried since I began my journey.

THE CROSSING

It was winter as the remaining three of us crossed the Himalayas to escape into India: my eight-year-old sister, a monk in his sixties, who became our guide, and me, a boy of six. The rest of our group were captured earlier in the expedition and taken away by the Chinese police.

At some point there were no trees on the steep mountainside we were going down. The stones were very slippery and we had nothing to hold on to. Because of the difficult descent, the monk told us to wait and he would go ahead to find the way. We waited and waited but he did not return. We began shouting for him. No one answered. My sister and I finally proceeded ahead, when all of a sudden we saw the monk's body in the canyon below, his fingers still clutching a handful of grass. He was dead. We cried for a long time and then we covered his body as best we could.

My sister advised me to climb back up the mountain to look for help while she stayed with the body. During the climb, I lost direction and could not find the road. When darkness fell, I called out for my sister. Again and again I shouted out my sister's name, hoping the winds would carry my voice to her. Nothing. I was so scared that I cried and trembled with fear. I found a cave inhabited by big birds, like chickens with long tails. I slept there for the next four nights without food or water. Each day I continued to yell for my sister. No one answered. On the fourth day, I heard hammering and left the cave to follow the sounds. They led to a power station and to a carpenter nearby, and then to the police, where I was held for two months before being sent back to my home in Tibet. My father returned to look for my sister, but no trace of her was found and she was given up for dead. A great sadness penetrated our home.

Time passed. I was twelve years old when I again tried to escape to India, this time with my younger sister and ten other Tibetans. The long and terrible journey took forty days. At last we arrived very early in the morning at the reception center in Kathmandu and fell asleep in the gardens. Two women came to awaken us and told us not to worry. I was sent to the Tibetan Homes School, and to my surprise my older sister was there, alive and well. Some monks had apparently heard her crying as they crossed the Himalayas for India and had brought her along.

Four years later my sister graduated. Unable to live away from our family, she returned to Tibet. Once again I do not know her whereabouts. I remain at the Tibetan Homes School determined to continue my education so I can help my country in its liberation.

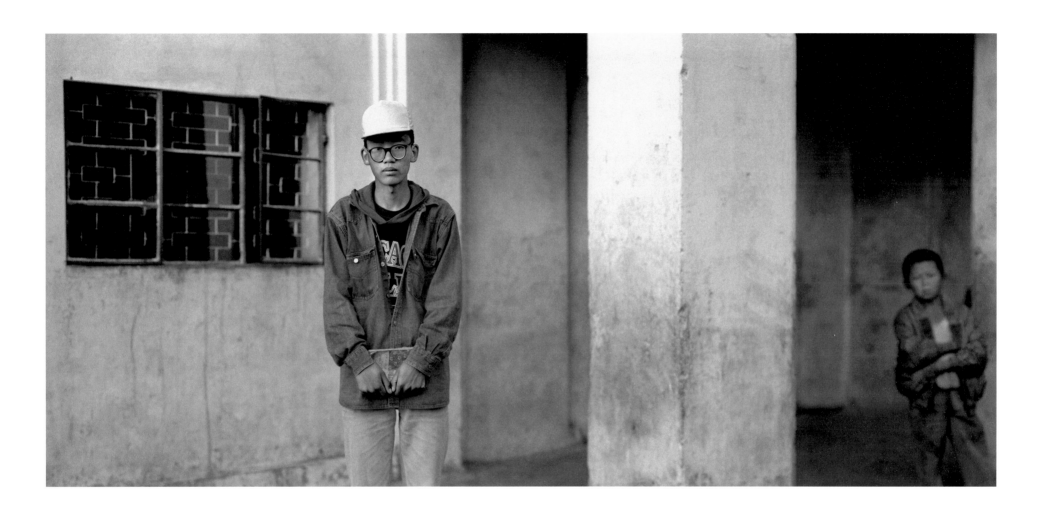

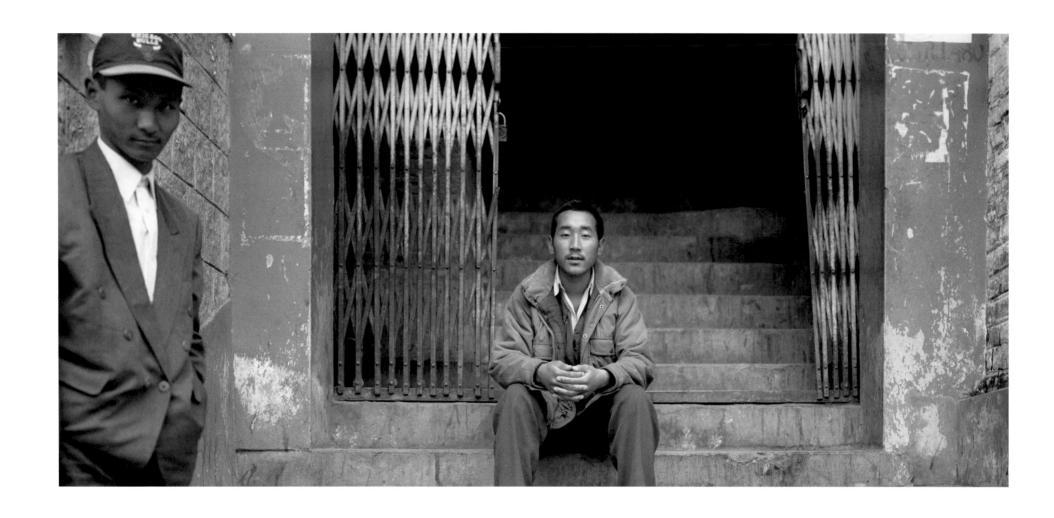

THE MONK WHO LEFT WITHOUT TELLING HIS FAMILY

Two years ago I became a monk and joined the monastery. The education was inadequate, because no proper Buddhist philosophy was being taught. Seven hundred monks occupied our monastery and there was so little food that sometimes I had to leave the monastery and go to my family's home to eat and to help with the farm work.

I had heard from friends that a person could escape to India and receive a proper education there. After some time, I decided to leave the monastery and go to India. Finding a guide is a very secret operation and I had to be very careful that I didn't get caught. I found a guide who charged me seven hundred Chinese yuan—about sixty-five dollars—for the journey. I traveled with seventeen other people. We took a bus to Sakya and from there we walked for thirty days and nights. It was November and the snow was up to our waists. We had no tents, and what little sleep we did get was done standing for ten minutes at a time against a tree or rock. For the first fifteen days of our journey we had little food, and for the latter part there was no food at all. We ate snow. Two members of our group who were also monks died from starvation and we hid their dead bodies in the snow. For days we walked on dangerous cliffs and rock ledges where one slip meant certain death. We had to take that route because there were less police in these areas and we were less likely to be caught.

I am happier now that I am in India. I am still poor but at least I am free. I have never told my family that I left. They think I am still living in the monastery. If I wrote to them, it might become a problem because the police would interrogate them about my leaving. It is better if my parents do not know where I am, for in this way they will appear sincere when they are interrogated. This is sad, but it is the proper thing to do for my family's safety.

Two Monks with Artificial Legs

In this photograph, my good friend, Nawang, is standing on the left. We are both monks who lost our legs due to frostbite. The pressure by the Chinese for monks and other Tibetans to denounce our country's independence as well as our spiritual leader, His Holiness the Dalai Lama, has been constant for many years. There were only twelve monks remaining in our monastery, and we were forced to enroll in special work units under the supervision of the Chinese police. We were having increasingly frequent meetings and re-education classes in Chinese history. The time for our formal renunciation of Tibet was only twenty-four hours away. We could not bear to denounce our beloved country and so we went home to gather our belongings in anticipation of fleeing to India.

In February of 1994, we began to cross the Himalayas on our escape. It was winter and the mountain peaks were like snow-white conch shells. After some time, we became disoriented and ended up wandering in the knee-deep snow for three days. We were lost. I was the first to lose all sensation in my feet, and by the third day I was unable to walk. I had to crawl in the snow, certain that I would die. Some nomads found us and they took us to their tent and gave us food and tea. Eventually, we ended up in a military base in Nepal and the doctors amputated the legs of my friend first. They told me my legs would also have to be amputated. For two months I resisted making a decision, but my condition worsened and, in the end, my legs were also removed. I spent the next six months in a prison in Nepal. Under normal circumstances, Tibetan refugees are returned to Tibet when they are caught by the police, but an exception was made on account of my situation.

I grieved for a whole year for my missing legs, and I felt angry and bitter. Then, almost overnight, I realized that this must have been my karma and my destiny. I recognized that this is what fate had brought me, for whatever reason, and that what was important was not my legs but my response to my plight. I have been at peace ever since. My friend and I hope to receive an education in India and to continue our work as monks.

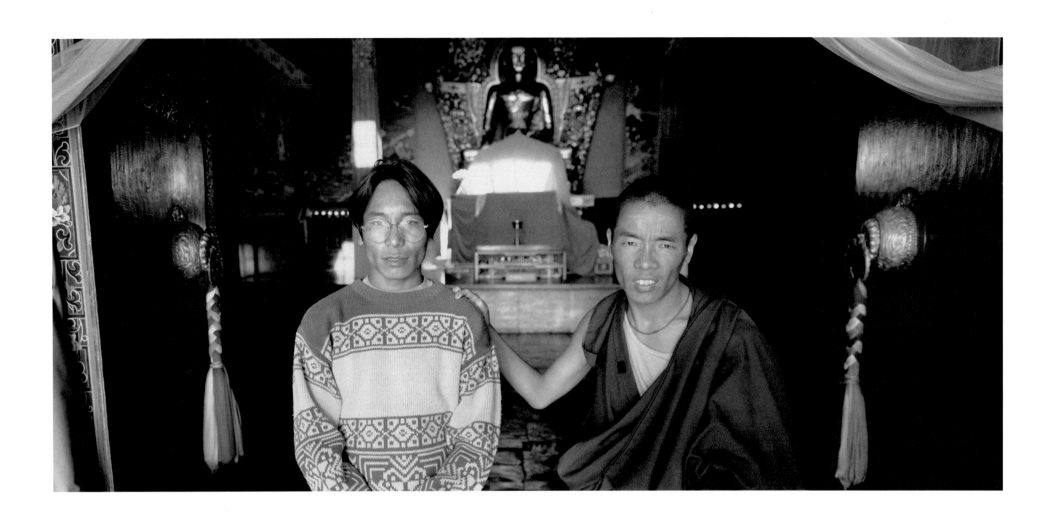

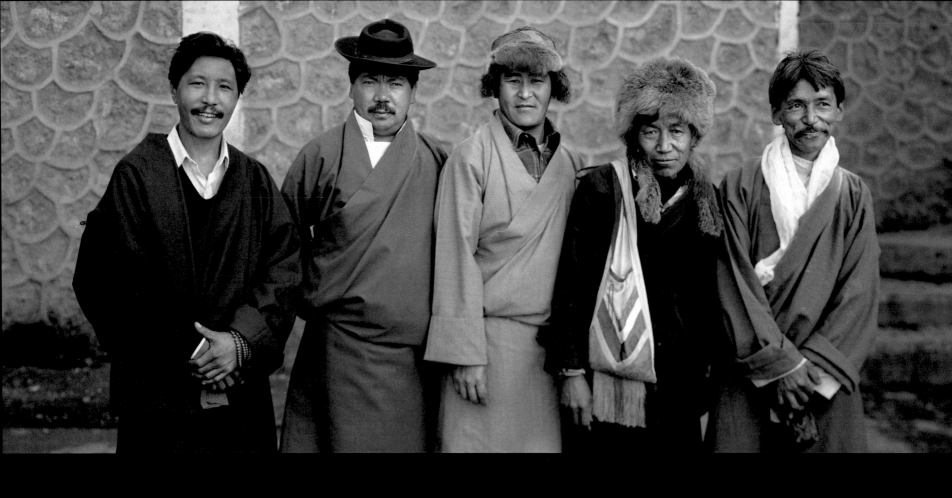

Five Tibetan Men, Mussoorie, India

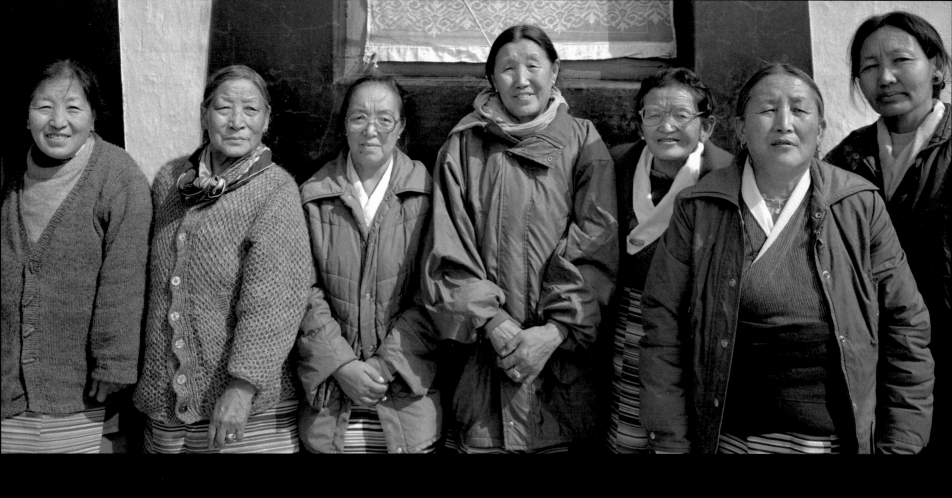

Tibetan Women, Mussoorie, India

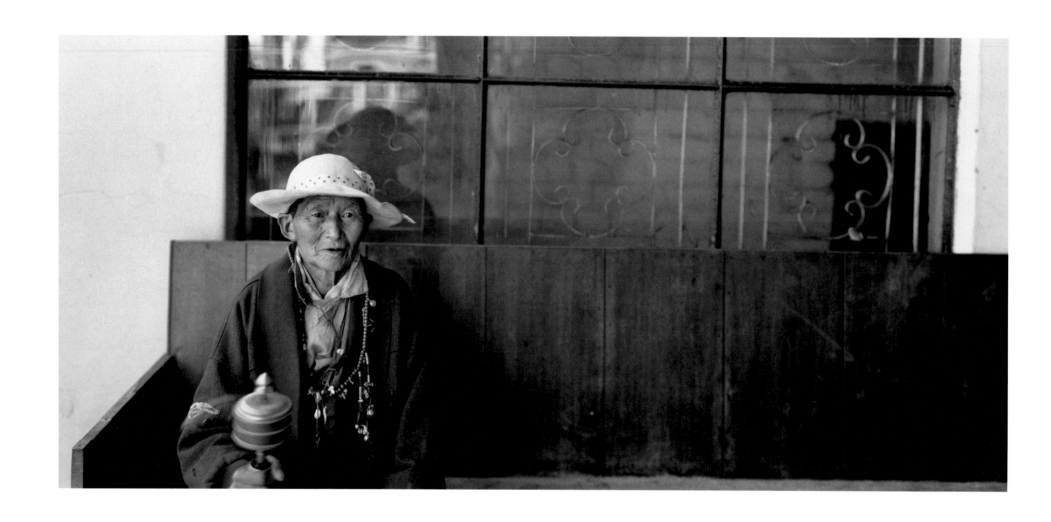

Tibetan Woman with Prayer Wheel

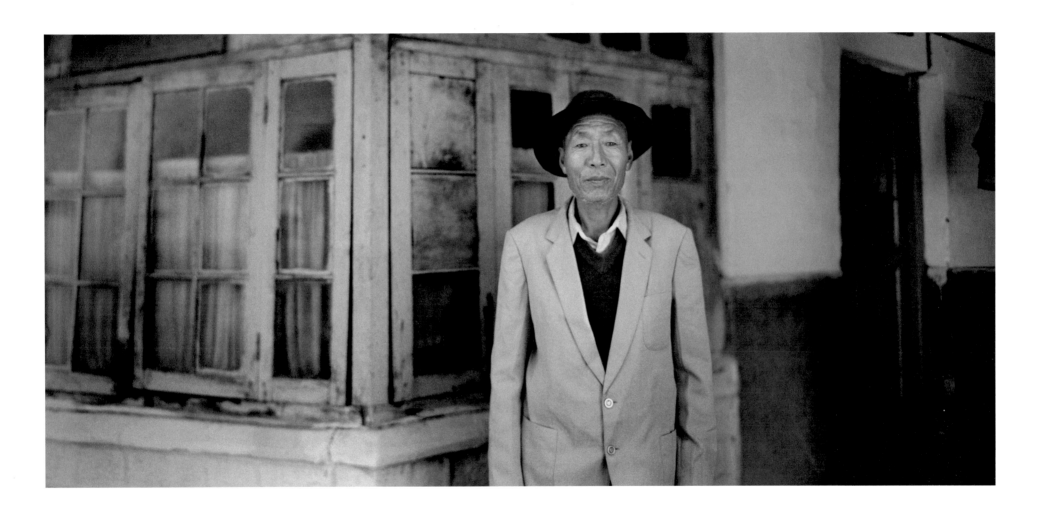

Tibetan Man with Hat

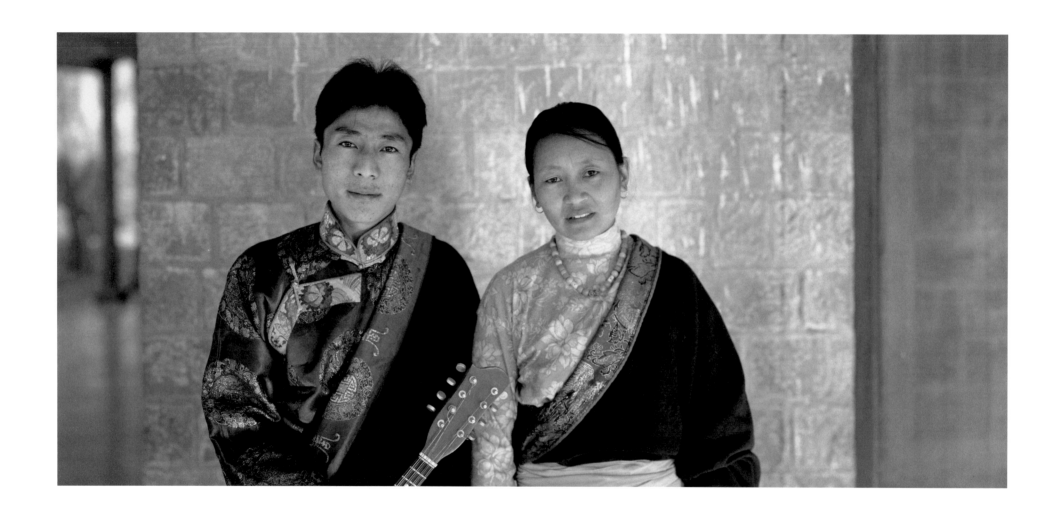

Tibetan Musicians

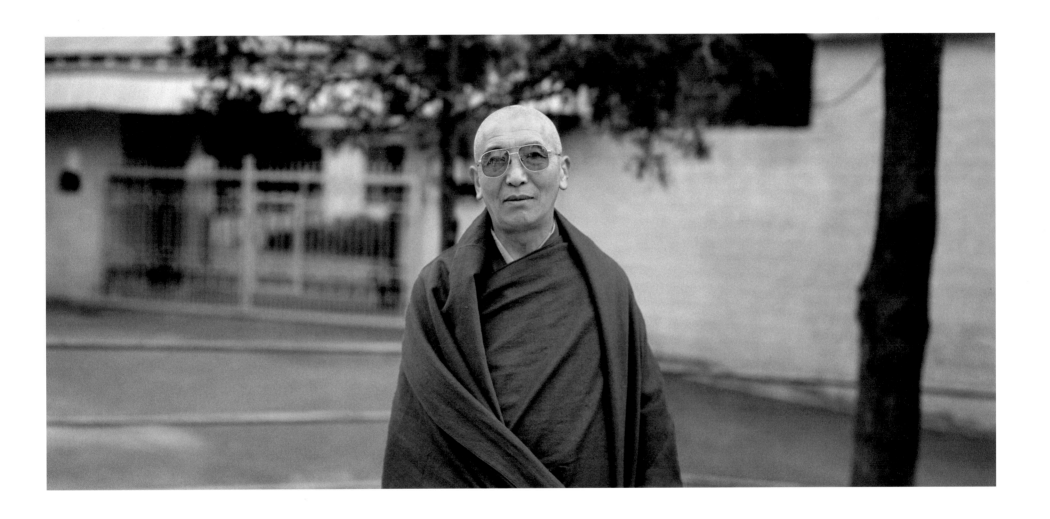

Tibetan Monk

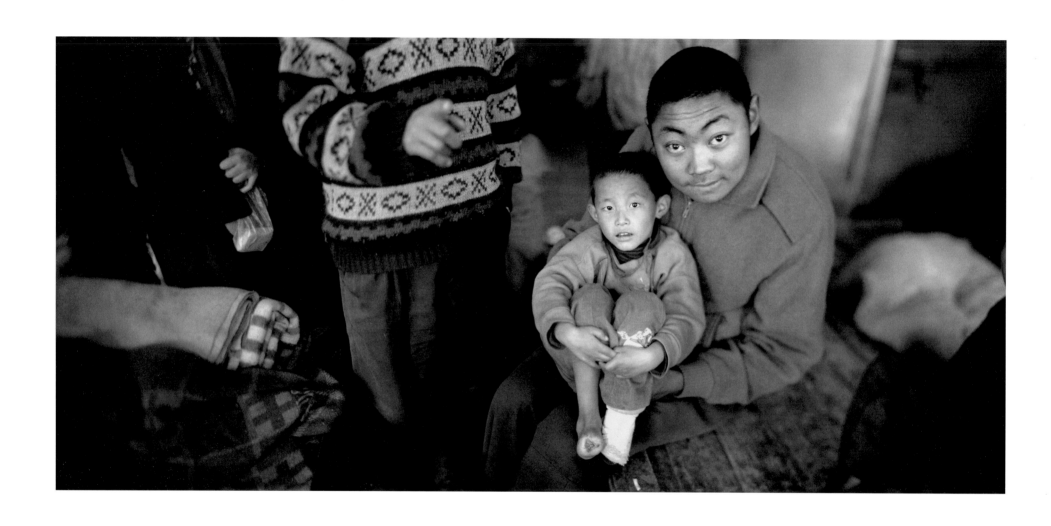

THE CHILD WITH AMPUTATED FEET

I am a monk, and I have fled from Tibet due to religious repression. I am seen in this photograph holding Tenzin, who is six years old. Tenzin's parents felt he would have a better life in India, so they sent him here with my group. They did not accompany him on this journey because they are very poor.

We left in the winter, as many do, since there are less Chinese and Nepalese border police at this time of year, and our chances of being captured were fewer. Our travels became difficult after fifteen days of walking due to a severe snowfall. We had very little food and many of us were starving. We had inadequate clothing and shoes. At one point, we came across a group of dead bodies, all Tibetans, lying frozen in the snow.

As the days passed, Tenzin's feet began to hurt. He lost all feeling in them, and when he could no longer walk I carried him. He became sick and we had to leave him behind with an old Tibetan woman in the mountains near the Shakmandu area of Mt. Everest. The guide intended to return in the spring and bring him back on the next trip.

A mountaineer later found Tenzin ill and dying, so he had his helicopter fly him to Kathmandu, where he was hospitalized for four months and where, as you can see, both his feet were amputated. This will make his life extremely difficult, since India is a poor country and two feet are very much needed. Tenzin's parents do not know what happened to him because he does not remember how to find them, and no one in our group knows them. It is unfortunate, but he will probably never see his parents again.

The Man with Painful Eyes

On my first attempt, I tried fleeing to India through the snow mountains with two of my school friends. Migmar, to my right, was one of them. The weather was clear and the sun was bright. After several days of walking in snow, we chose to stop and take a rest. We were feeling very hungry and thirsty, so my friends decided to make a fire with yak dung. While my friends went to gather the fuel, I walked to a nearby stream to get some water for our tea. I returned to our campsite to boil the water. Suddenly, sweat was pouring from my forehead and drops of water covered my face, and I knew there was something wrong with my eyes. I didn't know what was wrong and neither did my two friends. I couldn't eat or walk because the pain was so unbearable. My tears were like the river's water flowing, and my eyes were slowly getting swollen, until they shut and I could no longer open them. We found an empty stone house used by nomads in the summer and decided to remain there for the night.

That evening, I thought to myself, if my eyes stayed blind, how was I going to see His Holiness the Dalai Lama? As I thought about our great leader, a bright sunshine filtered into my dark world and brought comfort to my heart. The next morning, my friends each held one of my hands and we continued to walk through the snow mountains together. Eventually, the cold winds that blew on my face brought relief to my painful eyes.

At the border of Tibet and Nepal, we were turned in to the police and ordered to return to Tibet. They told us that going back was our only option, that if we tried to cross the mountains to India, death awaited us in the snow.

For several months, I worked hard helping to build irrigation ditches in Lhasa before looking for a guide to escape to India again. By this time, I was a little more experienced and was able to find someone trustworthy who would take me to Nepal, and with a group of twelve people we retraced nearly the same steps of my original attempt before reaching our destination in India.

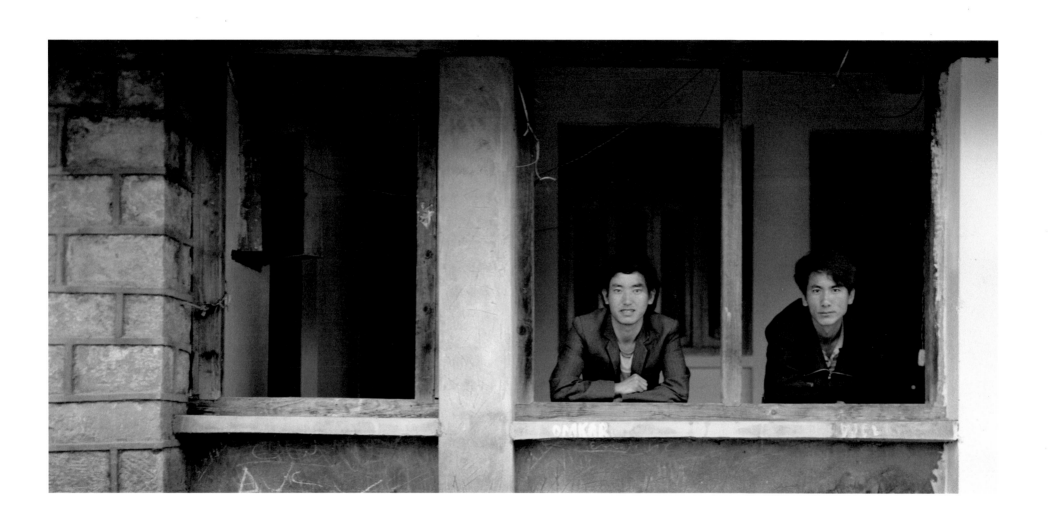

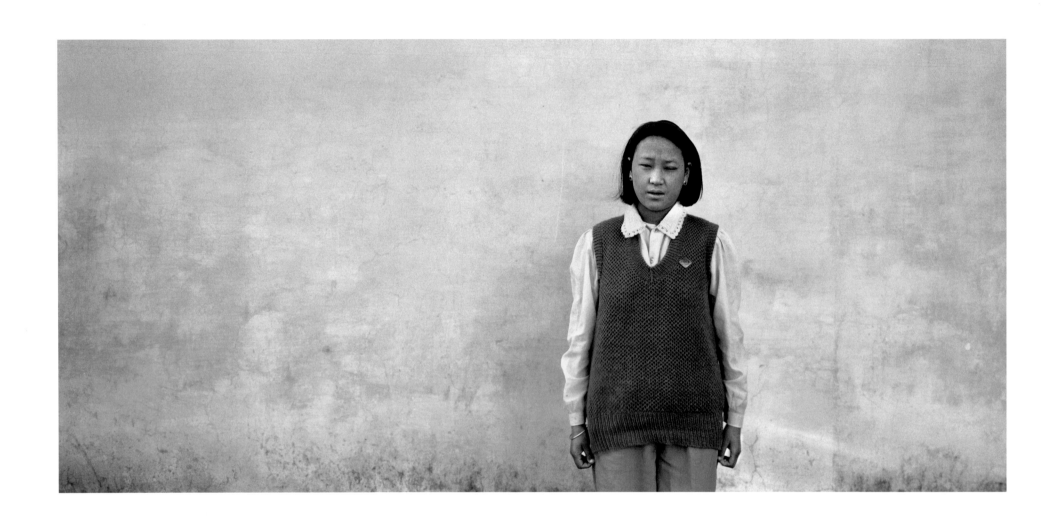

THE GIRL WHO WAS LOST IN THE MOUNTAINS

My family is poor and lives in Tibet. My father was a manual laborer, but he is no longer able to work because his health is very bad. My mother takes care of the household chores. The only person in my family able to work is my elder brother, who is a night watchman. He is paid twelve dollars per month. My other brother is mentally ill. My older sister and her husband live outside my family's home. He is a street sweeper and is paid ten dollars per month. My family saved their money and paid a guide to take me to India where I would be able to receive an education.

I was traveling with a group of eighteen adults and five children as we fled over the snow mountains out of Tibet. All I had with me was the fifty dollars my brother had given me for the journey. It had snowed for weeks and our group was caught deep in snow up to our waists. For three days we walked in this deep blanket of snow. My eyes burned and itched from the bright reflecting light, and at one point I became lost in the mountains. I wandered alone for many hours before I finally caught up with the rest of the group. My feet grew more and more numb until I had no feeling in them at all. Walking was difficult and I had to be carried part of the time. I don't remember much after that, but somehow I was admitted to a hospital at the end of my journey and they tried to save my toes with three surgeries. It was to no avail and the toes of my left foot were amputated. I am permanently blind in my left eye because of snow blindness.

My escape to India from Lhasa took seven and a half months. I am safe now. I am in school and I have many friends. I am finally getting an education and my family will be happy.

Dreams of Family
and Rainbows

Because of the Chinese occupation and ensuing repression, Tibetan families have become like seeds being thrown into the wind, scattered everywhere. In my four months in India, I never met one intact family where parents and children were living together under the same roof. Virtually all families are fragmented. Sadness always lurks beneath the happy smiles and laughter. The hunger and thirst for one's parents is ever present.

"I am a Tibetan refugee. I have no family and I have no country here in India. I feel very sad to live without my family. I feel very alone and I have nowhere to share my sadness. Sometimes I think that I want to escape from this place to go to my home country, but I have no money. I can do nothing if I return home. I miss my sweet home and I miss my sweet family. When you are a refugee, you cannot believe any person completely. Unless you are my parent, I cannot expect to believe you. My real father, for instance, would never say too many bad things to me. My real father would not lie to me. The problem I suffer from is that I can never really trust anyone completely." (15-year-old boy)

The longing, craving and yearning for family never subsides. Thoughts of their parents and family are present in every moment.

"Mother, I always pray to God that we may meet each other again in the future. When I came to India, I secretly brought a photograph of you with me. I keep it safely under my pillow and I always look at you before I fall asleep. I cannot fall asleep unless I first see you there in that photo. Sometimes I still cry when I look at you." (17-year-old girl)

The inner aches and pains of missing one's parents often begin in childhood, when these children may be ripped from their mothers' clutches to flee in stealth to India for a better life in their quest for education. They are brave beyond their years as they shore up their inner strength and maintain a stiff upper lip to carry on their families' dreams and aspirations. They may appear happy and secure from the outside, but they remain children at heart and cry an unspoken stream of tears.

Precious memories of family life long gone are savored and relished.

"Mother, when I first reached my school destination here in India many years ago, I felt very sad because you were not with me. In the night, I secretly cried myself to sleep. In those moments, I remembered how in Tibet we used to be so happy. I specifically remember you, my mother, because you gave me money and treated me so lovably as a child. I remember how you kissed me gently before I went to sleep each night. When I was ill, I remember you taking care of me and how you made me special foods.

N THE SKY

I remember the sweet memories and I wish our freedom would get here soon so that I can join you forever. Mother, do not worry about me. I have been here now for many years and I know that I can live without you and my father. Tell my father to continue to do good things for other people and to be sure not to work for the Chinese government. I am sad that you must continue to live under Chinese rule and that you have no country in which to be free." (17-year-old girl)

The recurrent night dreams of family reunions repeat their themes endlessly in every child's heart. The visions are always the same: reunion and the momentary reprieve from heartbreak.

"I have not seen my family for nine years now and I do not know their address. I feel like an orphan. I always dream that I am home with my family. Over and over, I dream that I meet my family and we eat and play together. I am always very happy in the dream, and once there was even a rainbow in the sky. I wish Tibet were free so that I could finally go home. When I finish school, I think I will return home to what is left of my country and my family." (16-year-old boy)

Every word, gesture and dream of years long past are clung to and treasured.

"Inside my heart, there is always a place for my family, an empty place, a black spot. Whether my life is good or bad, that black spot is always present in my heart. It is a dark and foreboding place. There is fear and longing there. I have a recurring dream that I go back home to Tibet and I am so happy to see my family. In this dream, my father always tells me, to my surprise, to go back to India to complete my education. I remember his words and my dream gives me guidance, even if I will never see my parents again." (25-year-old man)

The questions at heart are always the same: Will I ever see my parents again or will they die of illness or old age first? Why do I not receive their letters and do my parents receive my letters? Is my family well? As a child who cannot return to Tibet, what can I do for my poor and suffering family? These questions remain among the most wrenching questions in human existence.

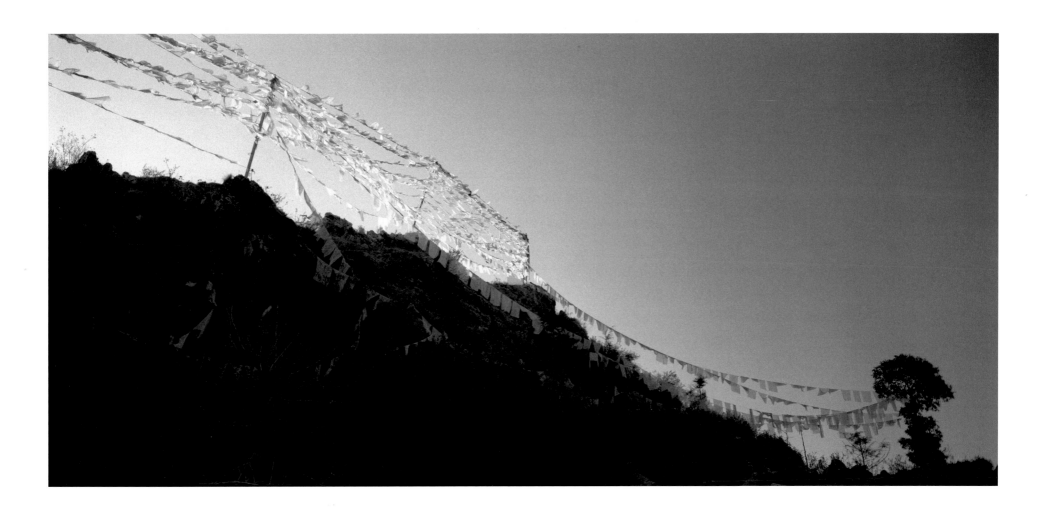

Prayer Flags, Mussoorie, India

Nomad Wearing Chicago Bulls Cap

I grew up in a vast grassland with yaks and a nomadic life. Nomads live purely on yaks. We get all of our supplies to live on from the yaks so we do not have to cheat our fellow human beings or destroy nature. There are no houses in the grassland because we move from place to place and we live in tents. The tents are made out of yak hair. The fuel for our fires is yak dung, which gives off extremely high heat but is smokeless and produces a pleasant smell when burned. Yak hair is also used to make blankets and rope. The yak's skin is used to make shoes, boxes and buckets. Yaks are also our main means of transportation, as they can travel for many days with a heavy load and little fodder. We refer to the yak as the ship of the grassland.

We make exchanges with nearby peasants for our other needs like salt, tea, sugar and barley. As there is no electricity, we use butter lamps to light our tent in the night. This is the way we nomads lived until the Chinese invaders came to the grasslands. Now life is very uncomfortable. We are taxed heavily by the Chinese. If a family has one hundred sheep and goats, each year they must give the government thirteen sheep and goats for taxes. There is barely enough left over to live on. I do not know why we must pay taxes, for we get nothing in return.

I left my nomadic life in March of 1996. I never told a single person, not even my parents. I just silently left. I miss the grassland, the cattle and especially the way we nomads lived. Life was simple and easy. By working hard, everyone was able to lead a peaceful life without deceiving or harming others. If there were no oppression or interference from the Chinese, a nomadic life would be one of the happiest and most sustainable ways of existing in the world.

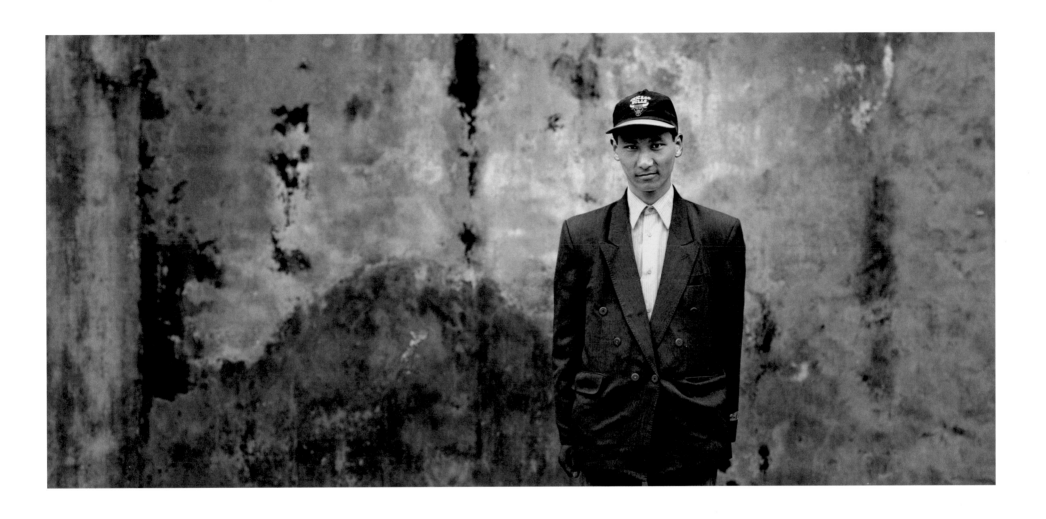

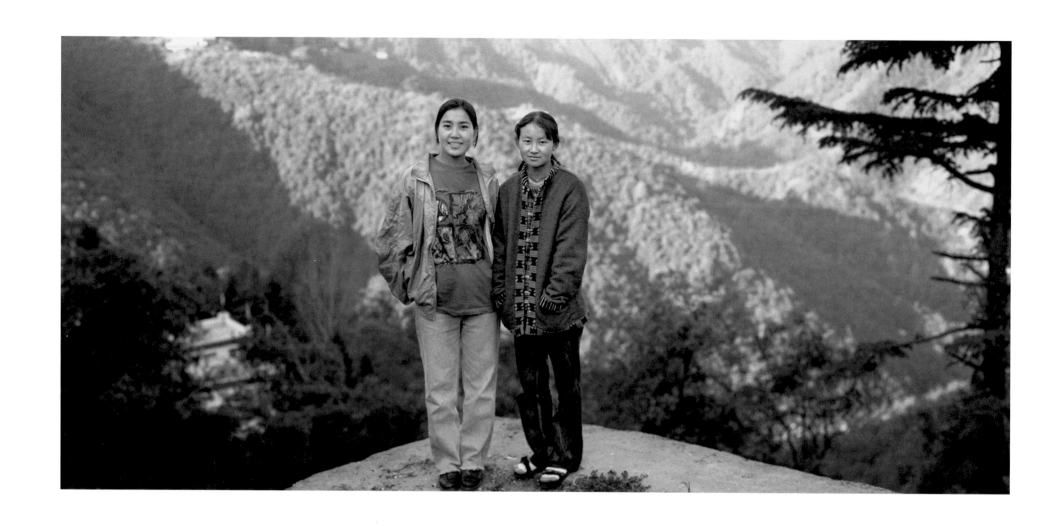

No Place to Share Secrets

I was born on May 4, 1978 in India, and you see me standing in this photograph with my hands in my pockets. My mother and father are both from Tibet. I was raised by the Tibetan Homes School from the age of five, so I know little about the life of my parents. I know my mother was short-tempered and she used to get angry very quickly. She sold sweaters and would leave home for several months out of each year. My father was a cook.

I had a baby sister whose name was Kalsang. She died when she was two years old. I don't know what happened. One morning my parents looked in on her and they told me she was no longer in this world. I don't know what was wrong with her.

My grandmother's husband died during a monsoon. He was walking and slipped on some rocks and fell. Afterwards, my grandmother died of tuberculosis. I cried when I saw her dead body. When I reached out to touch her, my mother hit me on the hand. "Don't do that!" she said.

In 1985, when I was seven years old, the worst event of all happened. My own mother died. I do not know how or why she died, but I remember her face remarkably well. No one talks about her. It was very hard for us afterwards because of never having enough money. We were always very poor. My father fell three stories off a building in 1993 and he has never been the same since that accident. After my mother died, my older sister raised me until she left for the United States to be married in Minnesota. It depresses me that I am apart from my sister, because I used to tell her everything. Now there is no place left to go and no one to share my secrets with.

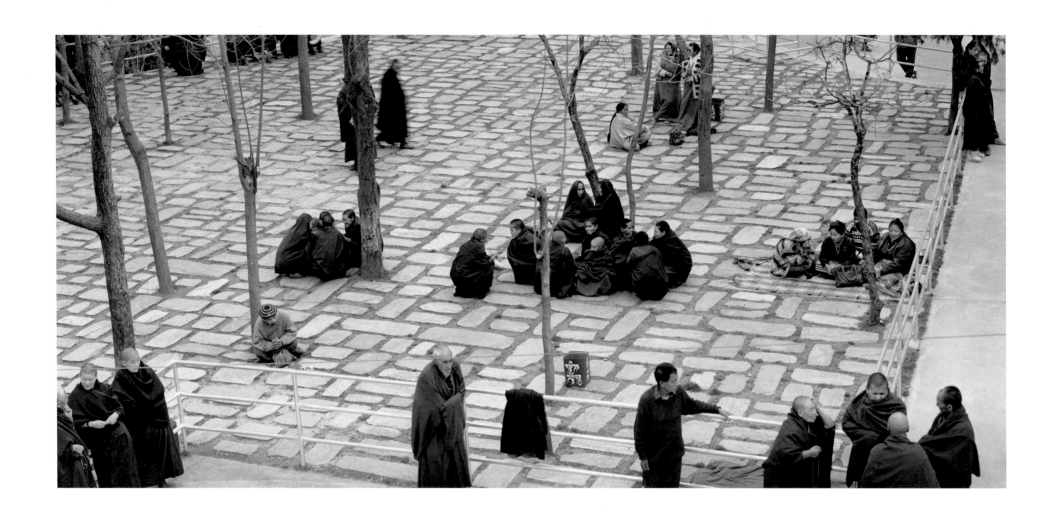

Courtyard I, Monks and Nuns Waiting for His Holiness

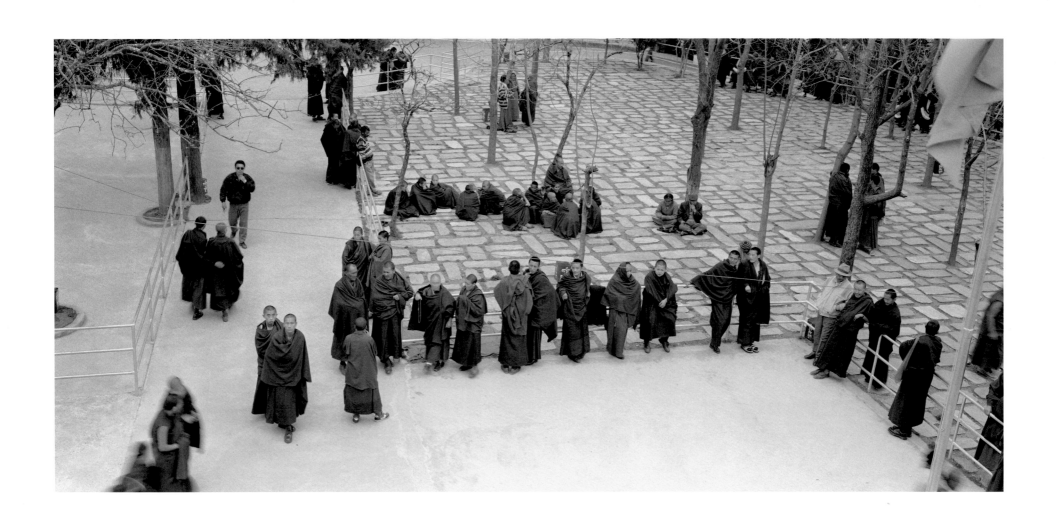

Courtyard II, Monks and Nuns Waiting for His Holiness

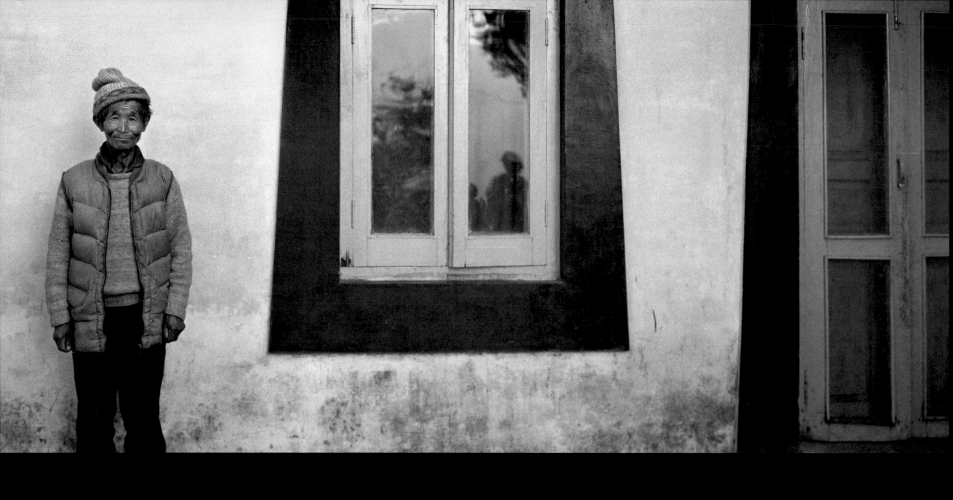

Caretaker, Tibetan Homes School, Mussoorie, India

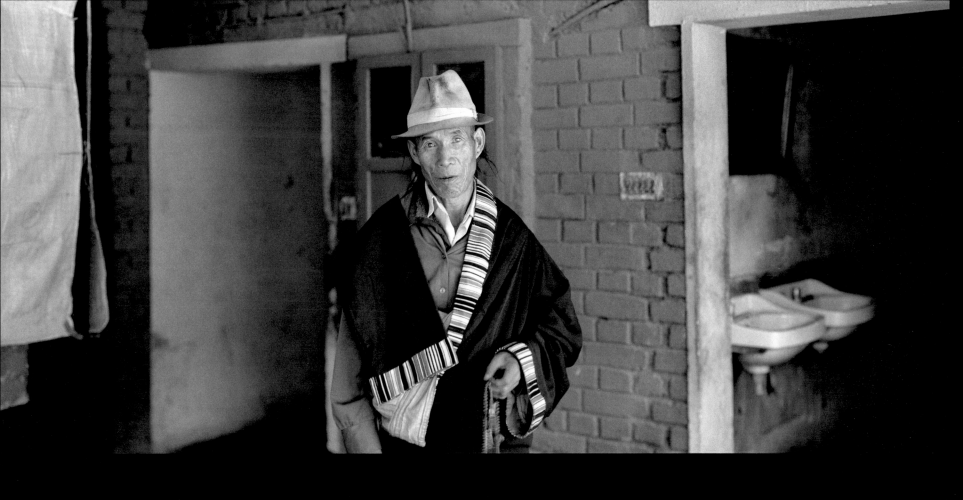

Tibetan Elder with Prayer Beads, Rajpur, India

The Boy with Many Questions

Tibetan parents are understandably afraid to talk openly to their children about the situation in Tibet because of the fear of retaliation. Free speech is limited even in the privacy of one's own home. During my childhood in Tibet, for example, I hardly knew that Tibet was occupied by China. I did not know why the Dalai Lama lived in another country. I did not know why so many Tibetans lived outside of their homeland. Nor why the Chinese collected so many taxes from the Tibetans, and why my family was poor. Whenever I asked anyone in my family about these things, my questions were followed by an awkward silence and went unanswered.

And then things changed very rapidly. My beloved mother died suddenly giving birth to my baby sister, who was stillborn. My father told me I would need to go to India to receive an education because of the communist ideology taught in Tibet. My father desperately wanted me to remember my Tibetan origins. And so I left my precious father and siblings and went to India when I was ten years old.

As I boarded the truck that would take me hundreds of rivers and thousands of mountains away, my father hid his face from me. When I asked him what was wrong, he turned to me silently, wiping his tears. Seeing this made me cry, so I held his hand firmly and tried to talk to him, but I was unable to speak because the sadness had put me in such a state that I could move my lips but no sound came out. My father also found few spoken words. However, with great effort, he was able to give me some parting advice. He told me to study hard and to write to him. I would proudly fulfill his former request within the next ten years, since I achieved high academic honors, but, sadly, not his other request, because I had no address for him and the nomadic regions of Tibet have poor communication.

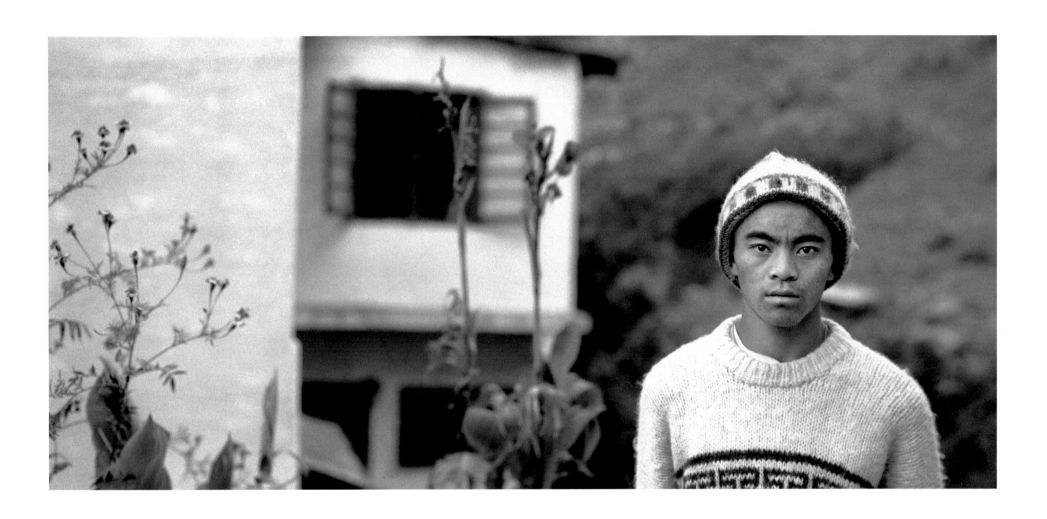

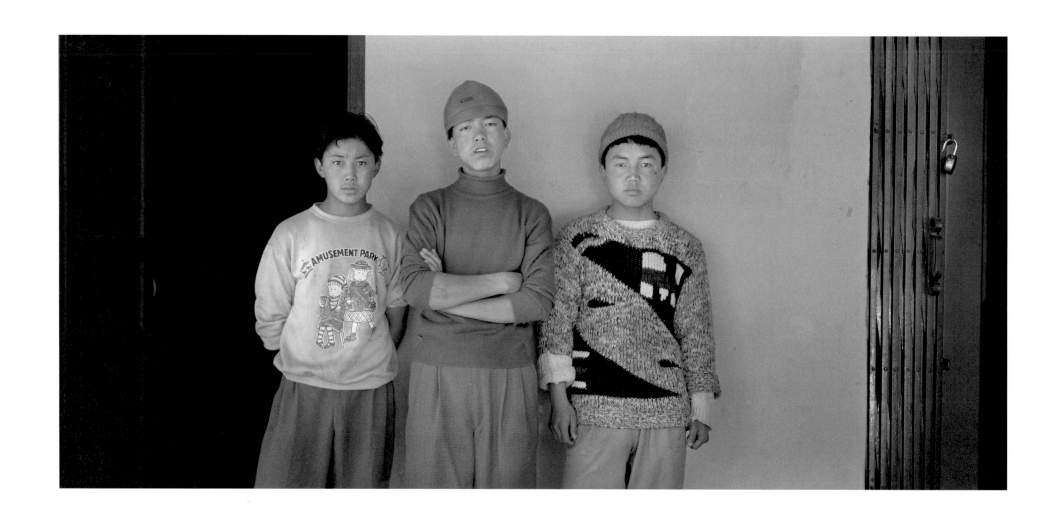

THE THREE BOYS WHO DREAM

We are Tibetan students residing in India. We are determined to become educated and to assist our country in its liberation. We dream of the freedom of our motherland. We also dream of being reunited with our families. Over and over, the night dreams always come to us: we have somehow returned in the night to our Tibetan village and we are reunited with our families. We are eating and playing and full of life. In the dream, we are happier than we have ever been in years, so happy that tears run down our cheeks. Joy is everywhere as we interact with our siblings. The thirst for our parents has finally been quenched, and if for only a moment, we have forgotten our loneliness.

We speak to our father and he advises us in matters important to young boys who are about to begin their adult lives. We speak to our mother and she embraces us with love. At long last, we taste the sweet feelings of safety and security deep within our hearts. These dreams of reunification are always very real and vivid. And then we wake up in the morning and the emptiness of longing for our parents also awakens. We wake to the sadness that never ends and fills our hearts with tears. We awaken to another lonely day following years and years of missing our parents. We awaken to unspoken suffering, to the painful feelings of loneliness and uncertainty and to dreams that have been kicked away. Distrust visits us constantly, because, as refugees, we can never really rely on anyone totally. Many of us do not know the address of our parents. We awaken to worry for fear that we will never see our beloved parents and brothers and sisters before they die.

THE NOMAD WHO LOST HIS TRANQUIL LIFE

I was a nomad in Tibet before I was imprisoned by the Chinese. On my release, I fled to India and I now work in an office building in New Delhi. It is a big change for me and I do not like the life here in the city. It is too busy and confusing. My old nomad's life was a wonderful life. It was so peaceful. I spent much of my time with animals. My family had over two hundred yak, seven hundred sheep and fifteen horses. We had two houses. Our summer home was a tent made out of yak hair that we used when we herded the animals into the mountains to feed on the green grass. In the winter, we stayed in a solid house to protect us from the cold. Our life was our own.

Then the Chinese came and took most everything away, even our family treasures like our jewelry and valuable clothing. My father joined the resistance movement and was shot during a struggle. I was about ten years old when he died from his stomach wound.

After that I continued to help my family raise the few animals we had left. The Chinese government taxed us heavily. I remember the Chinese police coming around to collect taxes in the form of cheese, butter and meat, and yak and sheep wool. They would come in the autumn when the animals were very healthy and strong. They intruded on our home, drank our tea, and threatened us if we didn't kill a yak and give it to them.

The life of my family fell apart even further when my sister, a nun, was raped by three Chinese policemen. They had been drinking. The police came to the door of our house several days later and I recognized the policeman who had raped my sister. Without warning, I attacked him and was arrested. I was nineteen years old at the time and was sent to prison for sixteen years. After three years I was released and fled to India. My sister dropped out of the nunnery and has never returned to being normal.

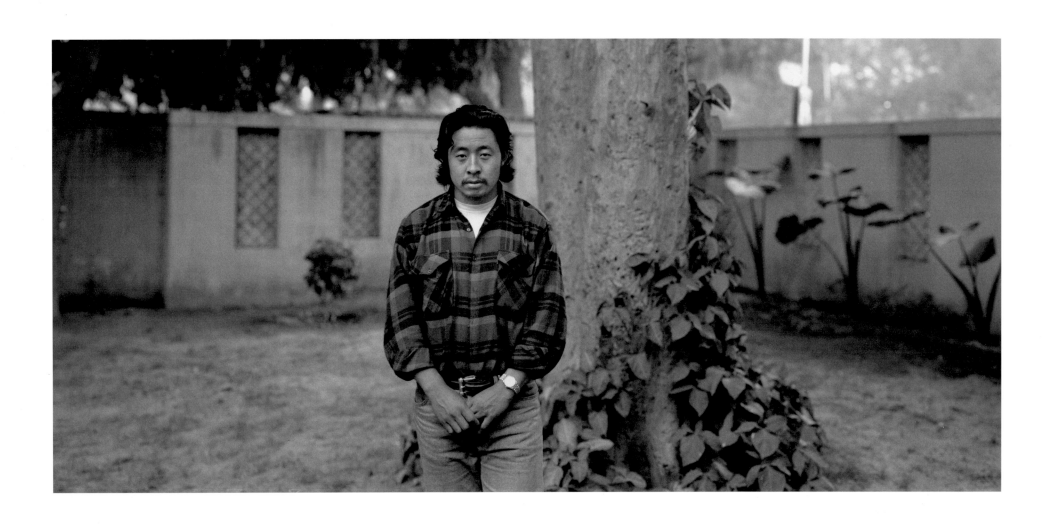

Heroism and
Undaunted Acts of

COURAGE

When I first arrived in Dharamsala, I was told by Tibetan officials about a young woman who had led her own demonstrations and had been in prison. She had resisted the Chinese police with fortitude and courage. The image of someone with physical features that were tall, prominent and substantial somehow slipped into my mind. I was thus understandably startled when I first saw Tsering. She stood at just over five feet tall. She was quite thin and appeared frail. Her features were refined and she did not look well. Her eyes were red from the visual damage of crossing the bright snow-capped Himalayas, and she squinted from behind her glasses as she looked at me. From her delicate appearance and stature, she certainly did not look anything like the undaunted freedom fighter she had proven herself to be.

When I met Tsering, she had just been released from a Chinese prison, where she had been incarcerated for three years for the single crime of raising a Tibetan flag. Her monk friend had been severely tortured for twenty-eight days and had, in the end, revealed Tsering's name. She was arrested, and like him she was brutally tortured for many months. She now complained of headaches, light-headedness and eye pain, which stemmed from the beatings she had received while in prison. And yet, on the very day of her release from prison, she had resumed her political activities in spite of possible re-arrest. The Chinese army, for all its might and power, could not vanquish this small, frail-looking woman who had spoken her mind. Even with violence, the police could not break her spirit. In the end, she would reveal no information to her captors and would continue to march to the sounds of her own drum.

Tsering will most likely never be famous, or go down in the annals of Tibetan history for her courageous acts of resistance against the Chinese regime. The world will not applaud her brave deeds, and few will congratulate her for her heroism. And yet, like so many other Tibetans, she has spoken out and voiced her opinions in a direct and forthright manner. She is just one of many thousands who have similarly selflessly risked their lives for the sake of their convictions and the injustices they have witnessed.

The struggle to speak out against oppression would be futile by rational considerations. After all, one might think, how much change could possibly arise out of the simple act of one person raising a flag or shouting a slogan? In Tibetan reality, the end result of such protest was predictable: imprisonment, torture and possibly death.

But heroism and passion fly in the face of reason and logic. Individual Tibetans by the thousands do in fact defy logic and raise flags and shout slogans in spite of immediate imprisonment. Not only that, but many would go to their death before their friends' and compatriots' names would ever be revealed to the police. The Tibetan prisoners would ignore compelling promises and bribes for instant release from prison in exchange for speaking out against the Dalai Lama and the Tibetan Government in Exile. Thousands of Tibetans would continue to hand out pamphlets, to demonstrate and to protest. Time and again I met individuals who were willing to risk their lives for a cause to the detriment of their own physical existence. I found myself secretly

wondering if I would be able to do the same. Probably not. But of course we never really know what we are fully capable of until we are confronted with the challenge.

From what place within us does this courage arise, this ability to sacrifice our life for a higher purpose? How can a nomad, unheard of in his day, suddenly awaken to become a potent force of rebellion and resistance and devote his life to the concept of freedom for his country and people? What is it in selfless actions that is so moving and inspiring? What draws, attracts and inspires us to acts of great courage? Why do some of us react to trauma in self-protective ways and others rise to the challenge and resist such temptations? What force in each of us is active here? Why do some men and women have the ability and the determination to do great and altruistic acts repeatedly over a protracted period of time? From whence does our heroism arise and how do we seek to unleash it?

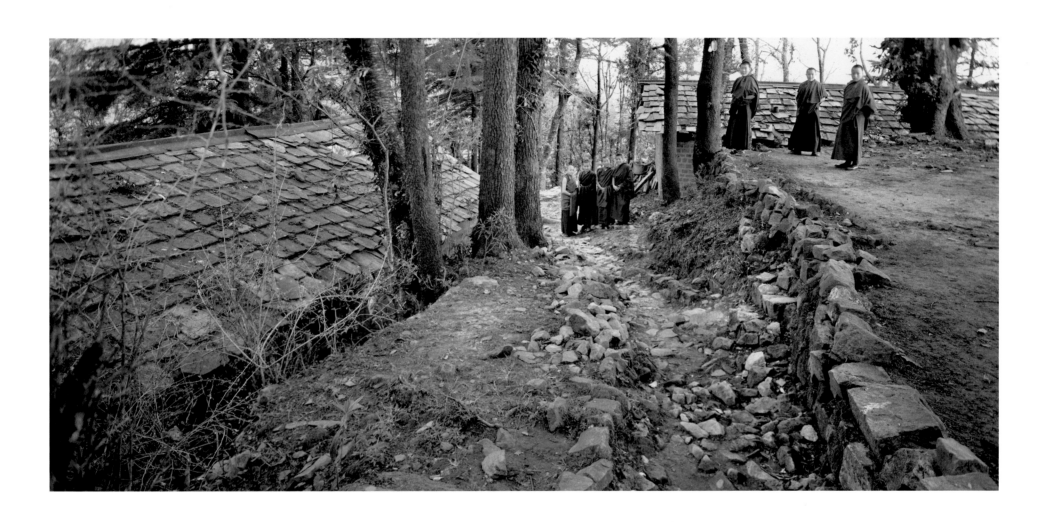

Seven Nuns, Dharamsala, India

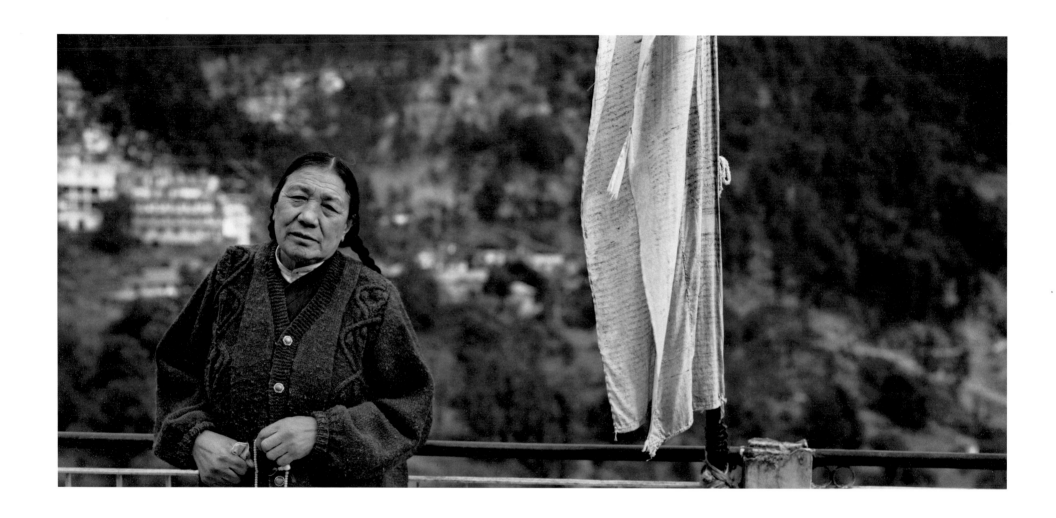

THE WOMAN WHO WHISPERED HER PRAYERS

My name is Ama Adhe and I am sixty-five years old. I spent twenty-eight years of my life in eight different Chinese prisons as a political prisoner. My chuba, which is the traditional dress of both Tibetan men and women, became my protection at night in the cold and dampness of my small prison cell. I used my sleeve as a pillow, one side of my chuba as a mattress and the other side as a blanket, since in many of the prisons there was no other bedding or blankets. Often, when I worked in the prison vegetable gardens that fed the Chinese guards, my chuba became a secret hiding place where I would store and conceal food to bring to the other prisoners who were starving. I was caught and severely punished for this on many occasions.

The inscription you see on the flag in this photograph is the Dolma prayer. I attribute my survival to the ceaseless repetition of this prayer. When I was first in prison, I tore a strip of cloth from my chuba and tied one hundred eight knots in it to use as a rosary. It is a tradition for Tibetans to count the number of repetitions of our prayers because it helps us to maintain our attention and concentration. The Chinese guards noticed this knotted cloth and beat me. Then I began to say my prayers out loud in my small cell. The guards waited secretly outside, and whenever they heard the sounds of my prayers, they would again beat me. And so I learned to whisper my prayers. When they saw my lips moving, the guards placed duct tape over my mouth. I learned to say my prayers with my fingers and in my mind. When they saw my fingers moving, they beat me and placed duct tape over my fingers to prevent me from counting. And so it was that I learned to pray silently in my mind without making any gestures so the guards could see nothing at all.

You May Steal My Body — You Shall Not Steal My Mind

I am Dr. Tenzin Choedrak, the personal physician of His Holiness the Dalai Lama. For thirty years I was a prisoner of the Chinese. At some time during my imprisonment, copies of Mao's "Little Red Book" were handed out. "For the next ten years, the book's contents were to be the principal topic of study, the Cultural Revolution having penetrated the prison as well. But though the return to conditions of near famine was distressful, the political shift which accompanied them came, ironically, as a blessing. The book, it turned out, provided a perfect vehicle for further recitation of prayers. By saying a mantra for every letter in a line and calculating the number of mantras at day's end, the entire cell was infused with a new spirit of hope. No matter how often they looked in, the unwary guards beheld all thirteen men poring over their books, apparently deeply engrossed. Even the slight movement of the lips—enough to have earned many prisoners thamzing [beatings] in the past—now appeared to be a sign of concentration on Mao's aphorisms." (From *In Exile from the Land of Snows* by John F. Avedon)

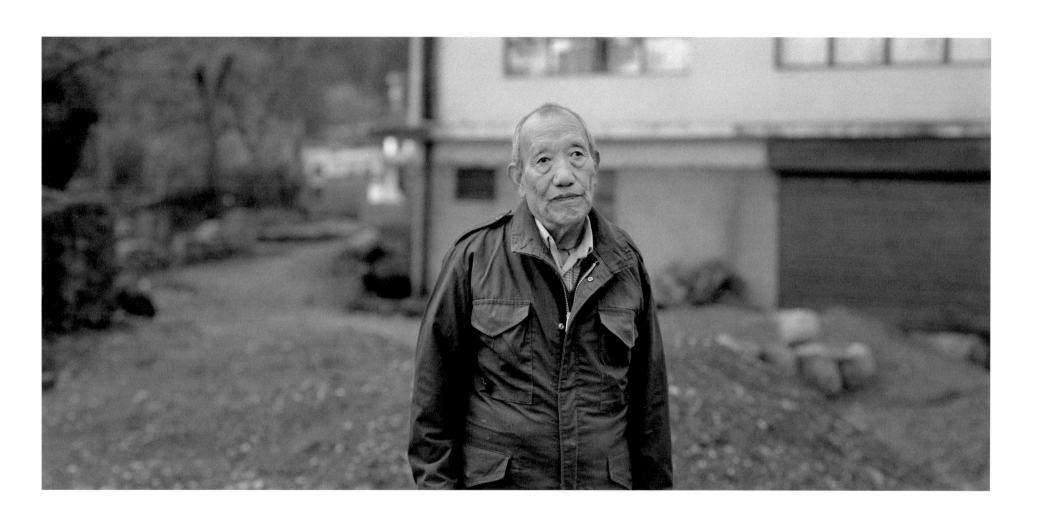

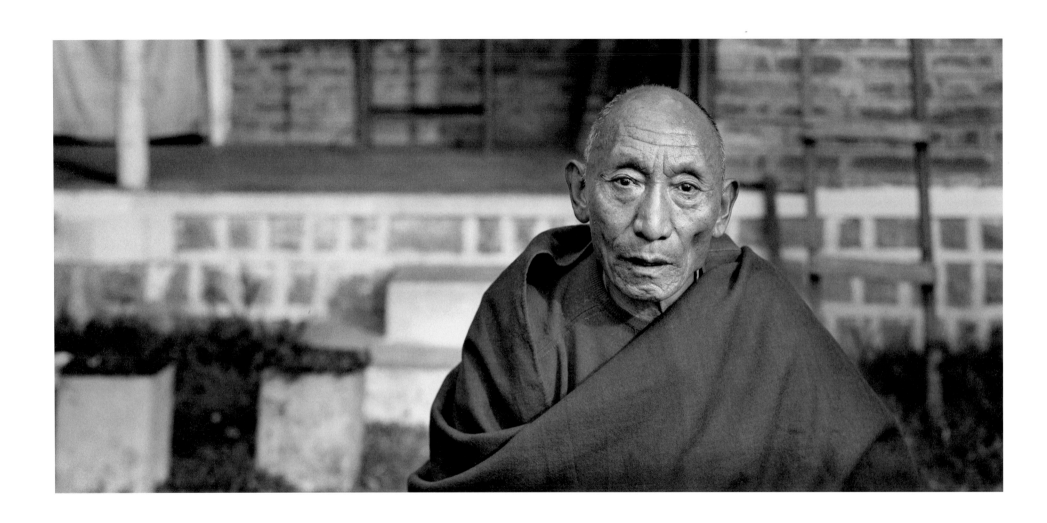

THE MONK WHO SANG IN PRISON

I am Palden Gyatso. I spent thirty-three years of my life in Chinese prisons and labor camps. During the time I was incarcerated, "the authorities decided that brutality was the only way to react to our rebelliousness. Guards began to use violence to punish the slightest infringement. But the prisoners were unyielding. They said openly that they would prefer to die rather than submit to the Chinese. It was a battle of wills. For those who use brute force, there is nothing more insulting than a victim's refusal to acknowledge their power. The human body can bear immeasurable pain and yet recover. Wounds can heal. But once your spirit is broken, everything falls apart. So we did not allow ourselves to feel dejected. We drew strength from our convictions and, above all, from our belief that we were fighting for justice and for the freedom of our country...

"In my prison, we used to sing, 'One day the sun will shine through the dark clouds.' The vision of the sun dispelling the dark clouds and our unbroken spirits kept us alive. It was not only prisoners who were resilient; so were ordinary men and women who lived their daily lives in the shadow of the Chinese Communist Party. Even today, young boys and girls who knew nothing of feudal Tibet and who are said to be the sons and daughters of the Party are crying out for freedom. Our collective will to resist what is unjust is like a fire that cannot be put out. Looking back, I can see that man's love of freedom is like a smoldering fire under snow." (From *Autobiography of a Tibetan Monk* by Palden Gyatso)

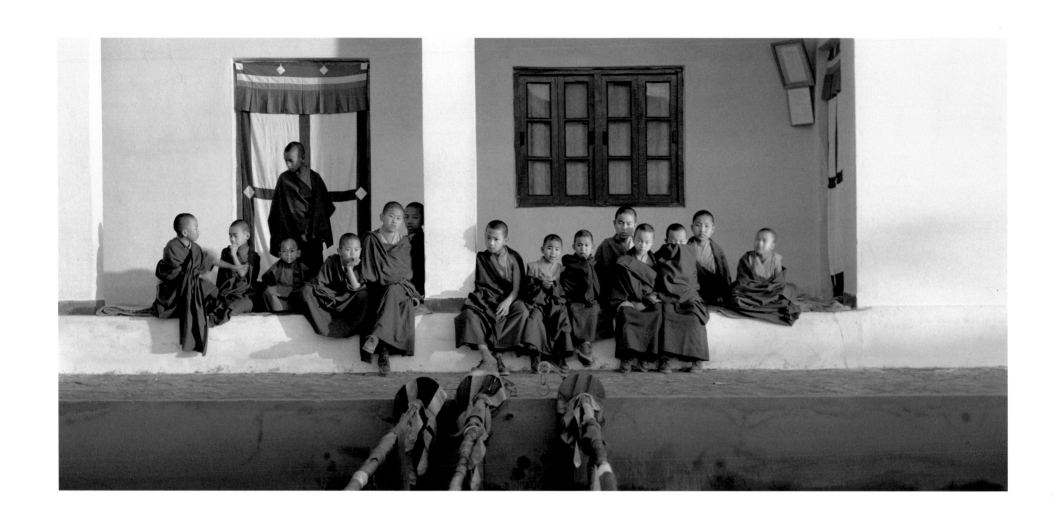

Child Monks, Clementown, India

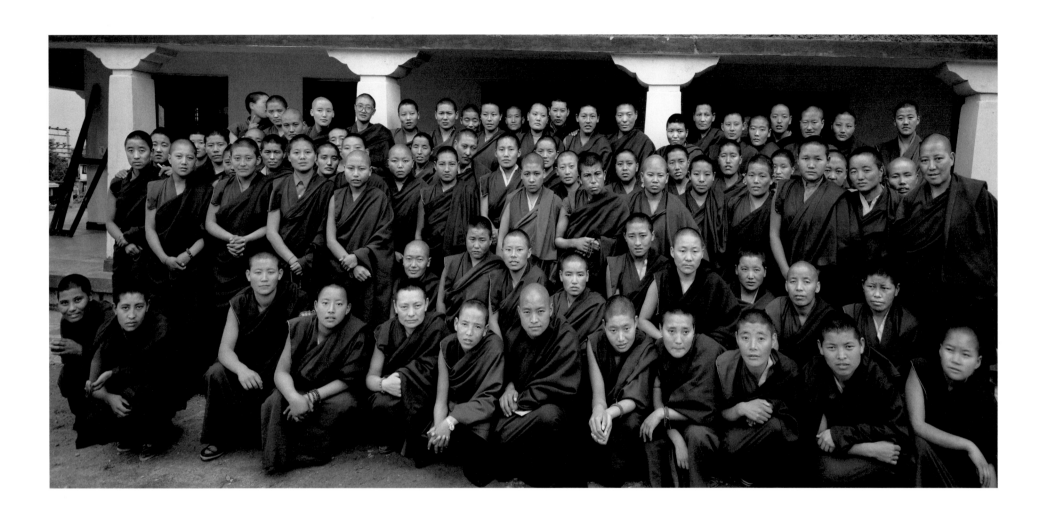

Nuns at Dolma Ling Nunnery, Dharamsala, India

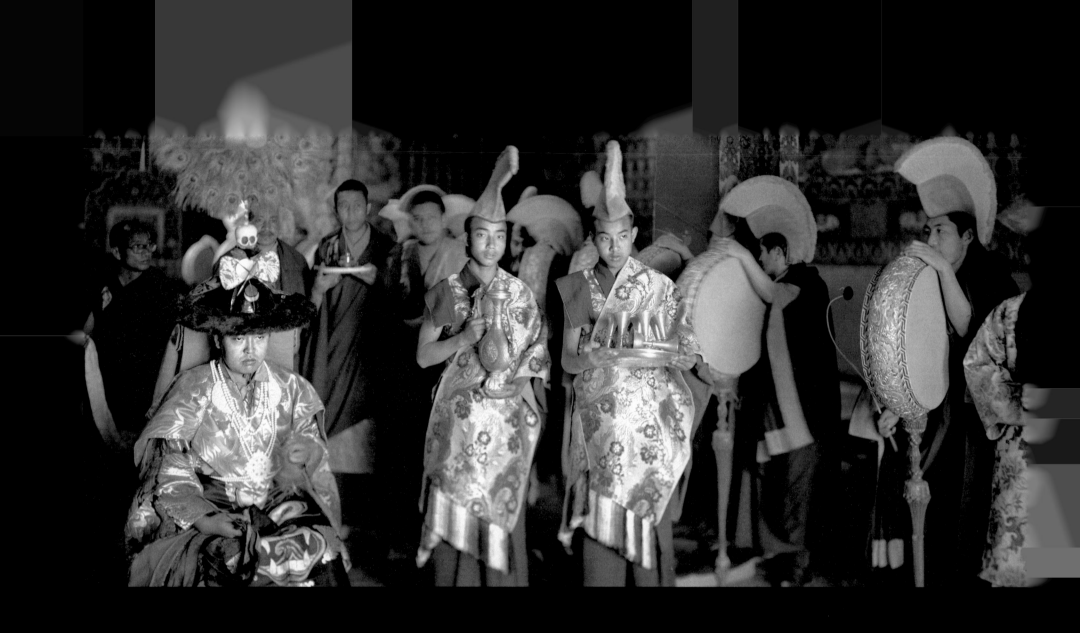

Religious Ceremony I, Clementown, India

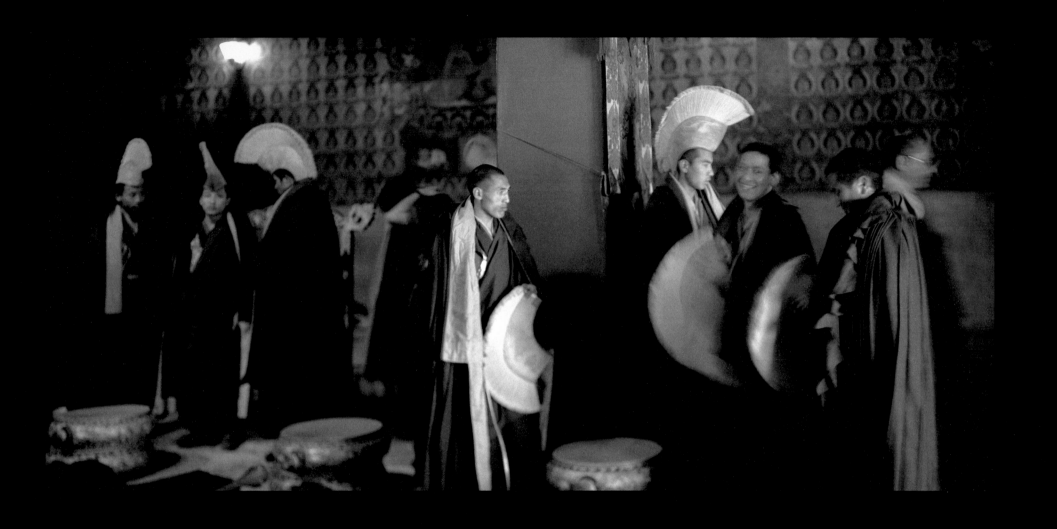

Religious Ceremony II, Clementown, India

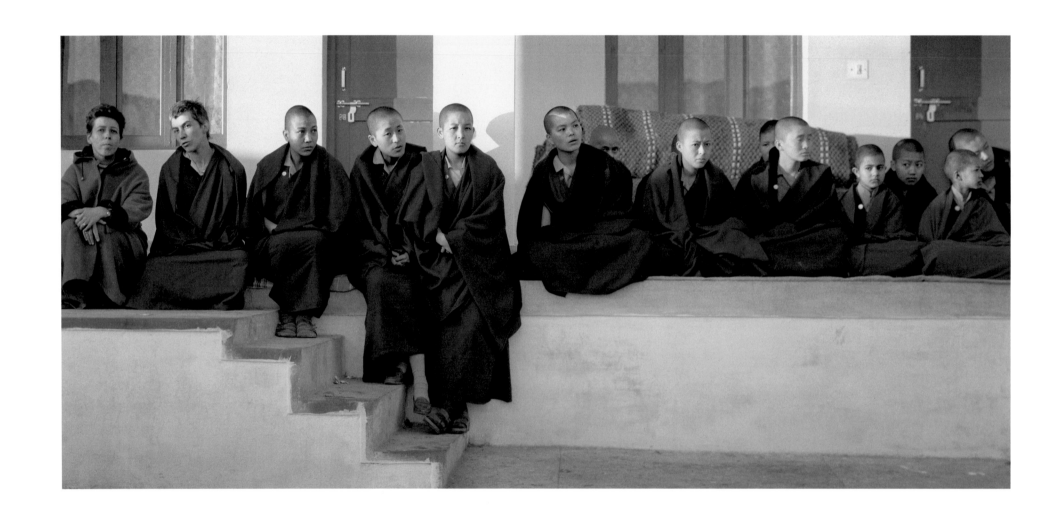

Monastics I, Clementown, India

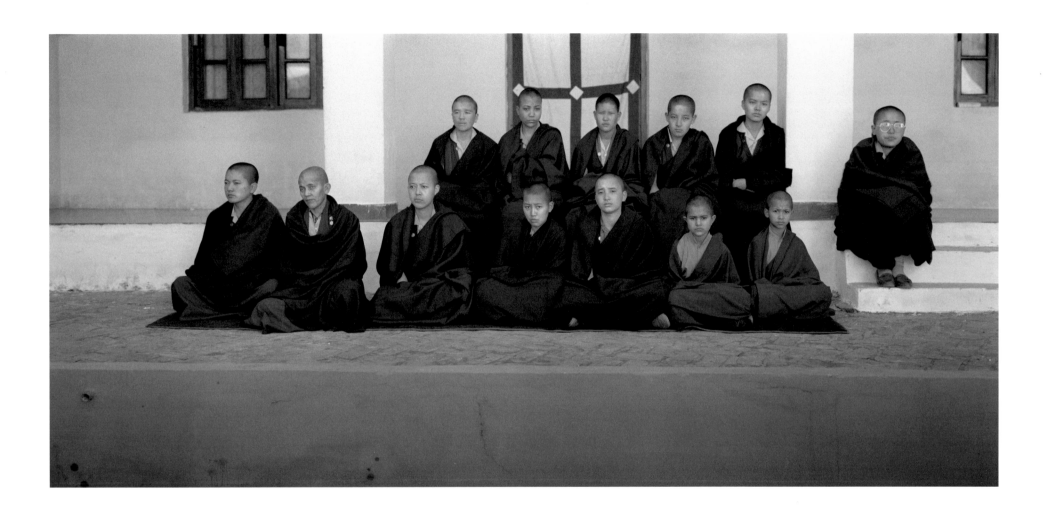

Monastics II, Clementown, India

THE TEACHER WHO RISKED EVERYTHING

By June of 1987 I had been teaching Tibetan and Chinese languages for five years. I was twenty-six years old and headmaster of a Chinese school, consisting of some two hundred students. I was also a student at the Chendu University. On June 13, there was a large one-time conference on the subject of sports and business held in the old northeastern province of Amdo in Tibet. I knew that many Chinese people from different provinces would be coming to this conference. Two of my students and I were determined to highlight the issue of Tibetan freedom and independence at this event.

We decided that we would put up four large posters and place them in strategic public places. The posters said in large letters, "Free Tibet" and "Chinese, Go Away From Tibet." We also planned to distribute two hundred pamphlets which read, "We Will Fight Unto Our Death." We planned our activities well in advance and carried them out without incident.

On February 28, 1989, the police arrived at my house, smashing all the windows and doors and confiscating all of my possessions. My two students were taken away and severely tortured until they told everything. One of them died secondary to the beatings. I was not tortured, but I was kept in manacles and interrogated over the next month. The questions were always the same: "Who is behind you in this?" "Who is supporting you?" "When did you get the idea to do this?" After one month, my hands were freed and I was released from prison.

I was not allowed to resume my master's degree in Tibetan or my Chinese studies at the university, nor was I allowed to return to my former paying position at my old school. After four months, I realized it was no longer possible to remain in Tibet, so I decided to leave and go to India.

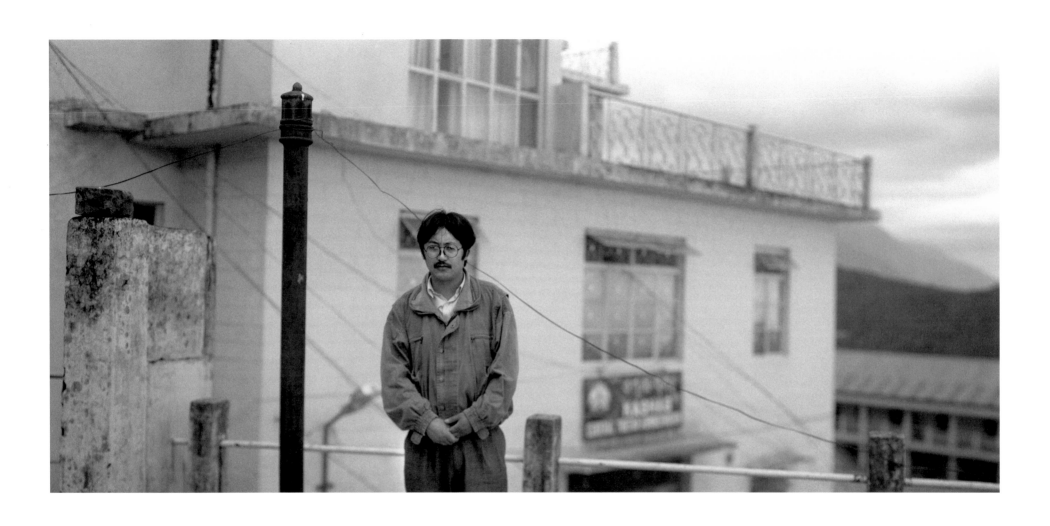

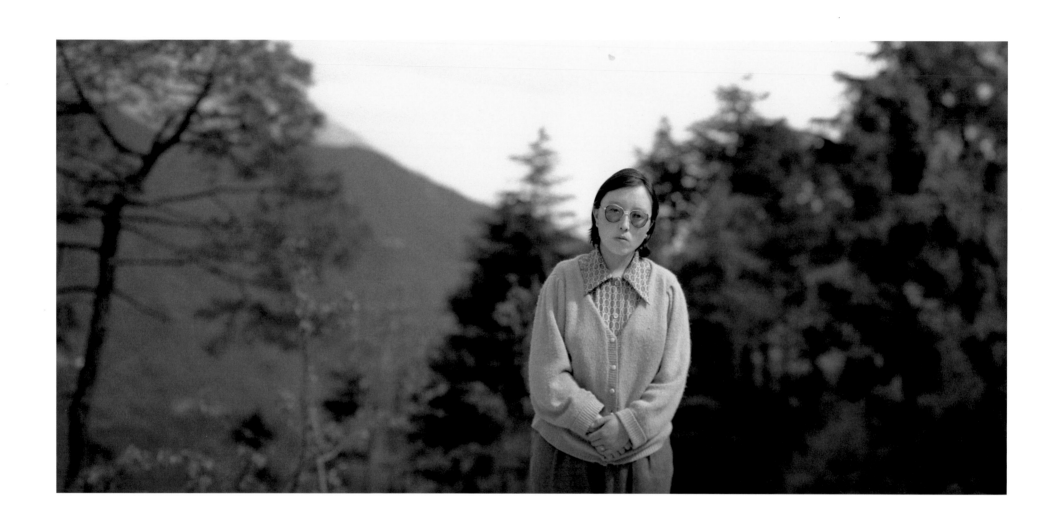

The Freedom Fighter

When I was thirteen years old, I participated in mass demonstrations to free Tibet. I saw many Tibetans killed. When I turned sixteen, I felt it was important that I do something more for my country. We were commemorating the Tibetans who had died in those demonstrations years ago. A friend of mine and I unfurled the Tibetan national flag on a monastery roof to celebrate this occasion. The flag measured three feet by four feet and flew for two hours. It was a glorious moment. Then the police came to take it down. My friend was arrested and sent to Gutsa Prison. He was badly tortured and finally, under force, revealed my name.

The police came to get me in the morning on the very day that I was to graduate from high school. They put me in Taktse Dzong Prison, which has the reputation of being the worst of all the Chinese prisons. I was tortured. They told me many times that if I revealed my friends' names, I would be released from prison, but I refused. I was promised that if I admitted that I had made a mistake and was sorry for my actions, my prison sentence would be reduced. Once again, I refused. Over and over during my interrogations I refused to do what I felt was a greater injustice, which was to speak out falsely against my heart and personal convictions. I ended up serving three years in prison, and from the many beatings I received, three months in a hospital. I never did reveal my friends' names or where I had gotten the Tibetan flag.

When I was released, I immediately began doing secret political jobs and increased my efforts to help my country. I was unable to get a paying job because I was marked as a troublemaker by the authorities. The Chinese placed my home under surveillance. The situation grew worse and my friends warned me of imminent re-arrest. Without telling my beloved family, I departed in the night. The next day, the police came to my house to arrest me but it was too late. I had already begun my escape to India.

My determination stems from the terrible injustices that are happening every day to my countrymen and -women. I will never quit fighting for the freedom of my country.

THE WOMAN WHO REFUSED TO SURRENDER

My father really wanted a son, but since I was not a boy, he would dress me up as one. Whenever my father went out, he was accompanied by six or more riders because he was a leader of our resistance movement against the Chinese. At such time, I would join them and carry a gun and ride horses in a man's apparel. I could handle guns and shoot fairly well.

When my father died, the other chieftains said that I would need to take over the resistance movement. So I took command of our forces. We rode day and night. The Chinese troops surrounded us and attacked us from both the ground and air. We woke up at dawn one morning, and as we were preparing tea, gunfire bombarded us. The Chinese were firing machine guns and we lost all of our possessions except for the saddles and the gold and silver ornaments we had on our bodies. We retreated and crossed the high mountain passes.

The Chinese pursued us. Another young woman and I stayed close to each other. She was also brave. We were both armed. We fired at the Chinese with our gun barrels side by side. I do not know if I managed to hit anyone. She did, and we continued to fire at the enemy. We had only two waist belts of bullets and the hills were littered with Chinese troops. We fired as economically as possible to save our ammunition, and we retreated on our horses.

We made a detour and rode for twenty days. We were under the delusion that American support would arrive, and so we stayed for two more months. There ended up being only eight American planes that air-dropped M1s, pistols, bazookas, grenades and radio sets. That was all the help we received.

Five days later, the Chinese mounted an offensive and dispersed us. We rode all night and crossed many mountain peaks in total darkness. The long ride was too much for my grandmother. We dismounted and I carried her piggy-back. I, along with two hundred other people, went on for twenty more days walking and riding over mountainous rocky terrain.

"Let the Chinese capture us but I will never surrender!" I told my grandmother. They did finally capture us. I never did surrender.

I spent the next twenty-one years in Chinese prisons. Although I went into prison as a young twenty-five-year-old girl, I came out as an old woman. After I was released from prison, I organized and participated in nine different demonstrations against the Chinese government before I had to flee from my beloved homeland.

A

GRACE OF BEING

t the Old People's Home, I watched the elders repeatedly struggle as they pulled their uncooperative and infirm bodies around the courtyard in a clockwise direction. Step by step for hours at a time. Weeks passed. One foot before the other, they dragged themselves forward in a determined, nonyielding manner. At one point, as I stepped beneath the dark cloth of my camera to make a film exposure, I couldn't help but notice their lips quivering, like flags in the wind, as they whispered and muttered prayers as fast as they were able. Their body movements may have been slow but the speed of the prayers was not. Sitting, socializing or at rest, their lips and fingers continued to move nimbly, like deer through the forest, as their fingers bounded over the beads. Even while eating meals, one hand would lift the food while the other hand moved the beads over gnarled limbs and fingers. If meaning in one's life is related to the intensity and determination of a goal that is of paramount personal importance, then I would not hesitate to say that all the old people I met had lives filled with meaning. They were rushing against the clock of their ultimate destination to complete as many prayers for peace as possible in any given segment of time. We would describe them as happy. They were all certainly busy and there was no time for retirement.

Naturally, such fervent intensity is grounded long ago in childhood. When I arrived at any given school, the first thing the children would want to show me upon my arrival was nothing less than their prayer room. They would grab me by the arms and drag me bodily to see these barren and hollow rooms with just one or two photos of religious Tibetan saints and a white cloth. "This is where we pray!" they would gleefully exclaim, bristling with pride, "and this is a photograph of His Holiness the Dalai Lama." Not just one or two children but all of them over and over again. Not just children but young adults as well. Passion and excitement were always evident in these hundreds of children chanting their daily prayers for hours at a time. Religion was everywhere, and I never met a Tibetan for whom expression of love for religious life was not intensely felt. It was as if each person had a significant role in the creation of world peace and took on the role very seriously.

For the monks and nuns, religious intensity was demonstrated not just in the many nunneries and monasteries but in the prisons as well. When I asked what they were doing with their minds as they were being tortured, the response was always the same: they were focused, to the best of their ability, on the Dalai Lama and praying for world peace—not an answer I ever expected, for beatings coupled with prayers for world peace do not easily coexist side by side. Most Tibetans understood, at least at some level, that these guards who once beat them were under the influence of the communist belief system. In many cases they described feeling sorry for the guards because these same guards would inevitably reap the consequences of their cruel actions. The Tibetans voiced their understanding that the prison guards themselves were victims of ignorance. In light of this, it is understandable that they were not so filled with anger or hatred for the Chinese, since they were at some level capable of understanding the predicament. They attempted, as is their

usual practice, to flood their minds with thoughts of peace, compassion and prayers for humanity. With images of His Holiness the Dalai Lama to sustain them, they viewed their beatings and torture within a much broader context: they viewed their suffering as intrinsic to life itself. It was important for them to hold to this belief and not surrender to feelings of retaliation and hate. When anger and hatred did arise in their minds, compassion was the antidote.

I kept noticing that there was an infectious happiness here that I was not able to explain. No one had told me about this beforehand. As I mentioned earlier, before I came to photograph the Tibetans, I knew literally nothing about their culture. But as I became embedded in so many of their lives, the thought kept occurring to me that these people should not be so happy. They had been stripped of their families and country, and many had been tortured for long periods of time in prison. Where was their anger? Why were they so happy and lighthearted? In the nunneries, for example, I repeatedly felt as if I were on a child's playground, so effervescent were the nuns, and yet many had been in Chinese prisons and all were separated from their families. This is not to say that there was no sadness. When speaking of the atrocities, they were indeed distraught and tearful. But I did not see bitterness and hatred. I did not observe the focus on retaliation or the dwelling on the past that I would have expected. Somehow, their culture had given them tools and incentives for letting go and seeing life in a broader perspective. After all, it is our perspective as human beings that colors our feelings and determines our responses. If we see ourselves as having been wronged and blame someone else, then we will spontaneously seek retaliation and retribution. If we view our respective situations in life as faultless, that is, as a part and parcel of living and as a consequence of our actions, then we can focus on letting go and moving on into a better future. This message has value for all of us.

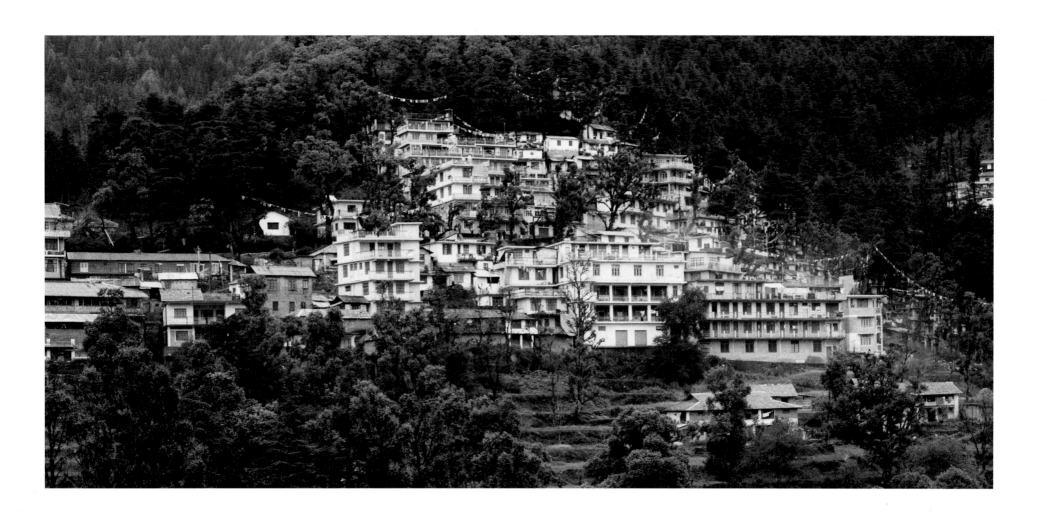

Village of Dharamsala, India, Location of the Tibetan Government in Exile

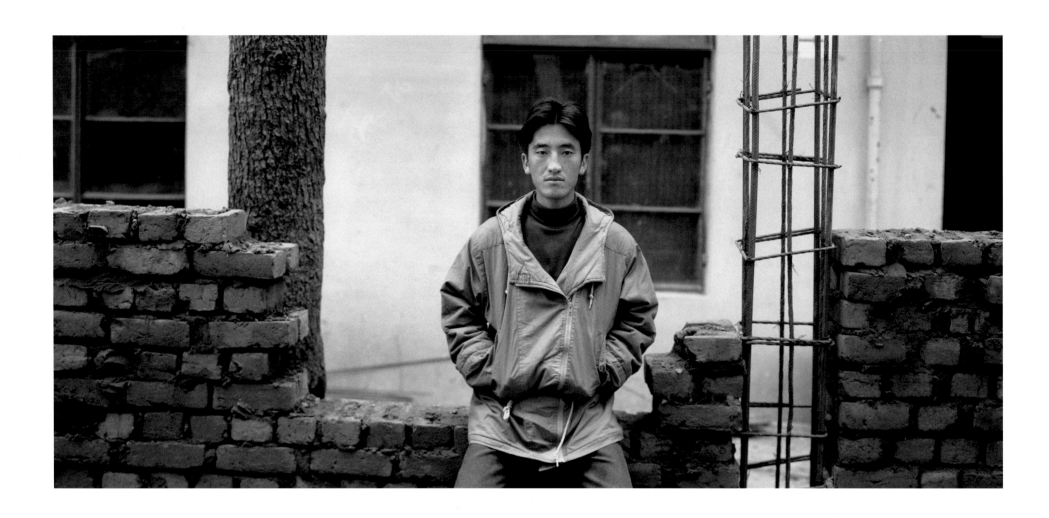

A MEETING WITH HIS HOLINESS

It is considered the greatest achievement to be able to see His Holiness the Dalai Lama in one's lifetime. Many thousands of young and old alike travel by foot from Tibet over the high mountains each year for the sole purpose of being in the midst of our spiritual leader. It is the event and dream of a lifetime and there is no experience greater than this to the Tibetan people.

So it was with myself. Just before the Tibetan New Year in 1993, I received permission to have an audience with His Holiness. Sitting in the middle of the prayer hall, I felt my body shiver with excitement. My eyes twinkled as my mind ran rapidly over the idea of what it would be like to be near him. A great happiness was growing deep in my heart. I looked around and realized that everyone in the room was experiencing the same feeling. Quiet, peace and anticipation filled the beautiful hall. The only sounds were coming from my heart pounding loudly inside my chest. At that moment, there was pindrop silence.

Suddenly, I heard someone crying, then another and another. The crying was muffled, quiet and deep. A chill ran from my head to my toes as I listened to that sound. Then, without warning, a cool line of tears ran down my face from my eyes. It was a deep cry, and to this day I do not know how the tears began. Perhaps it was suffering, happiness and joy all mixed together reflecting the feelings of each and every one of us. Perhaps it was the flowing blood of six million Tibetans.

Several monks appeared on the stage in front of the hall. One monk was carrying a pot of incense. Emerging from behind the smoke of the incense was His Holiness. My first memory is of the smile that hung on his face, that smile expressing such honesty, peace, purity and respect. I heard his greeting, "Tashi delek," with his beautiful laughter. His voice reached each person's ears and each person's heart, and made the crying become even louder. His voice was like hot water being poured over my body, like a sweet seed being sown in my heart. My mind traveled back to my home and I tried to remember my entire family as though they could be sharing this moment with me. Then we received his blessing and we were all very happy.

THE OLD WOMAN WHO TOLD THE FUTURE

My name is Magic Momo and I am eighty-two years old. In this photograph I am standing with my grandson. He is all I have left in the world because his mother was killed in a truck accident in New Delhi. The rest of my children died long ago of polio.

I was married when I was twenty-five years old to my neighbor's son. I did not want to get married, but my mother promised our neighbor that I would marry her son. In those days, all Tibetan marriages were arranged by our parents. I could not say no. We had a daughter, but later I caught my husband cheating on me with one of my cousins. I left him and refused to ever remarry. Marriage is not easy.

I am known as Magic Momo because of my gift to read the future from my prayer beads. I feel guilty when people ask me to read the future because my vision is bad and it is difficult for me to count the beads. But I feel compassion for them so I try as best as I can. The doctor tells me I need an operation on my eyes, but when I ask my beads, they say I should not get such an operation. So I put tape over my eyes instead to keep the skin from falling down over them.

I do my Buddhist religious practice every day. In the summer, when the days are long, I repeat thirty thousand prayers each day on my prayer beads. In winter, when the days are short, I am only able to do eleven thousand prayers. My beads used to be quite a bit larger but years of use have worn them away. The cord that binds my beads together has broken five times over the course of my lifetime.

The first forty-seven years of my life, before I left Tibet, are only happy memories. My life was good and I can recall only joy. Now that our country has been stolen from us, my life is very difficult. I can't stop thinking about my daughter and I feel very sad much of the time.

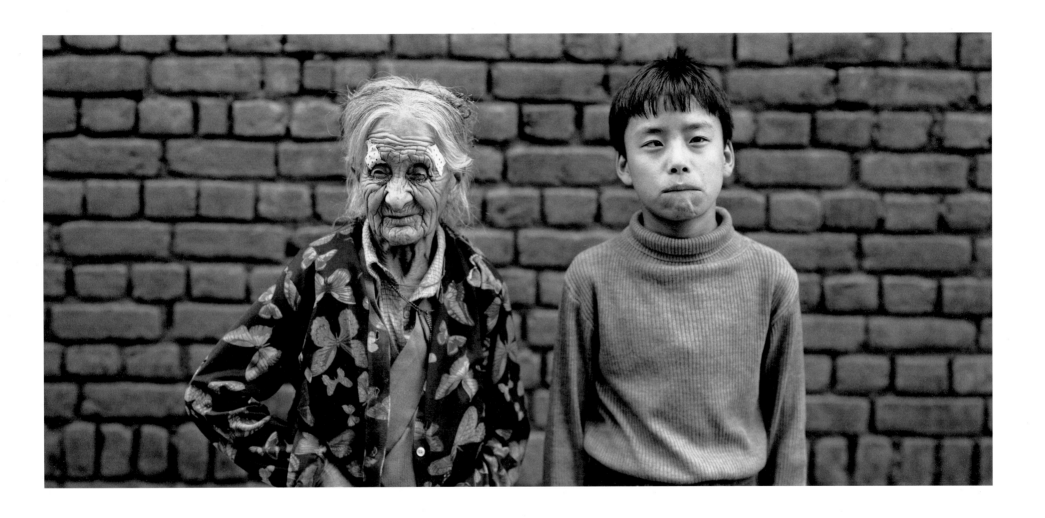

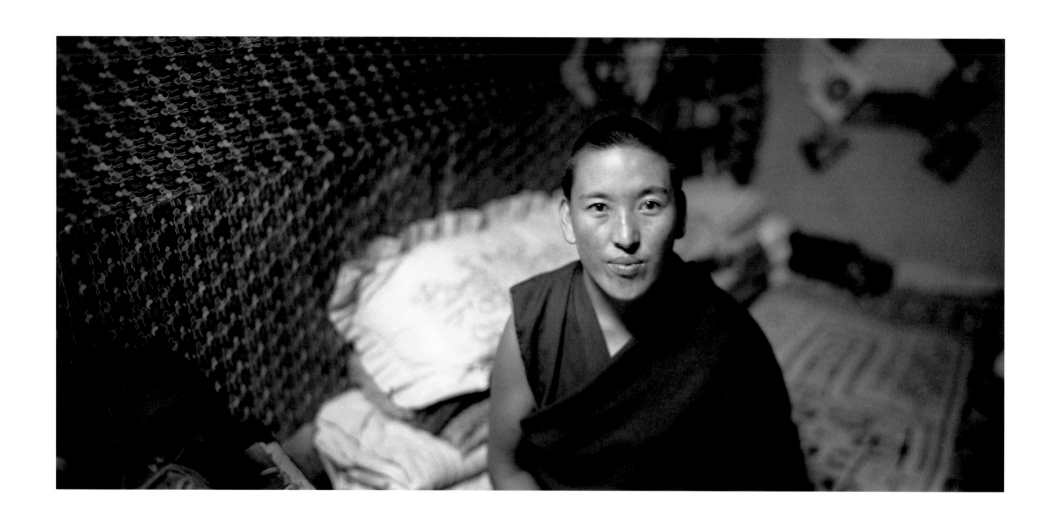

126

The Nun Who Meditated in Prison

When I was in Tibet, and as life worsened and many Tibetans were being executed, my friends and I formed a group called Free Tibet. There were twelve of us. We were all nuns and I was the youngest. One night, we created and put up a total of five posters which read: "Free Tibet!" "Stop Destroying Tibet!" "Don't Stop Buddhist Religion!" Certain young men who helped our group had underground connections with the Chinese police. They told them about our posters in order to receive a reward of about thirty dollars. At midnight, the police came to get me and placed me in a Chinese prison for the next three months.

During the interrogations, which took place about twice a week, I was beaten and tortured. To stay alive, I meditated on peace and nonviolence every possible moment that I could. I tried my hardest to think of His Holiness the Dalai Lama and of peace for all humankind. Again and again, I meditated on my prayers. I did not feel particularly sad or angry. If the police noticed my lips moving, they told me to stop or I would be punished further. So I whispered my prayers secretly, barely moving my lips at all.

A group of us celebrated the Dalai Lama's birthday in prison by singing traditional Tibetan songs. As punishment for this action, the Chinese guards put me in an ice house and removed my clothing for three days. Then the beatings resumed and they went on and on for weeks. My prayers for peace and nonviolence also went on and on, with even greater intensity.

Finally, my parents pleaded with the Chinese officials to let me go. After three months they relented and released me. My other friends who were also in prison had no mothers or fathers to fight for their release, so they had to remain in prison for two or three more years.

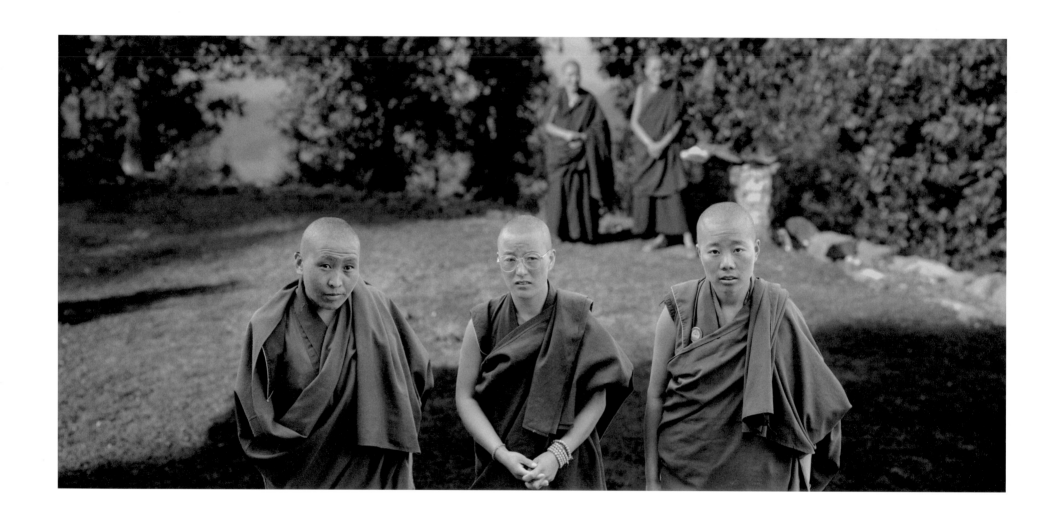

Nuns, Dharamsala, India

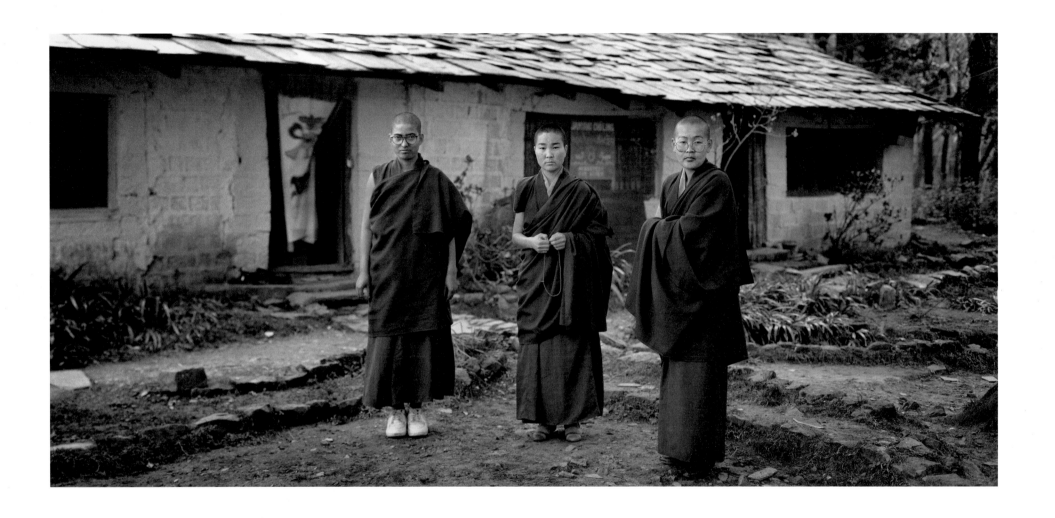

Three Nuns, Dharamsala, India

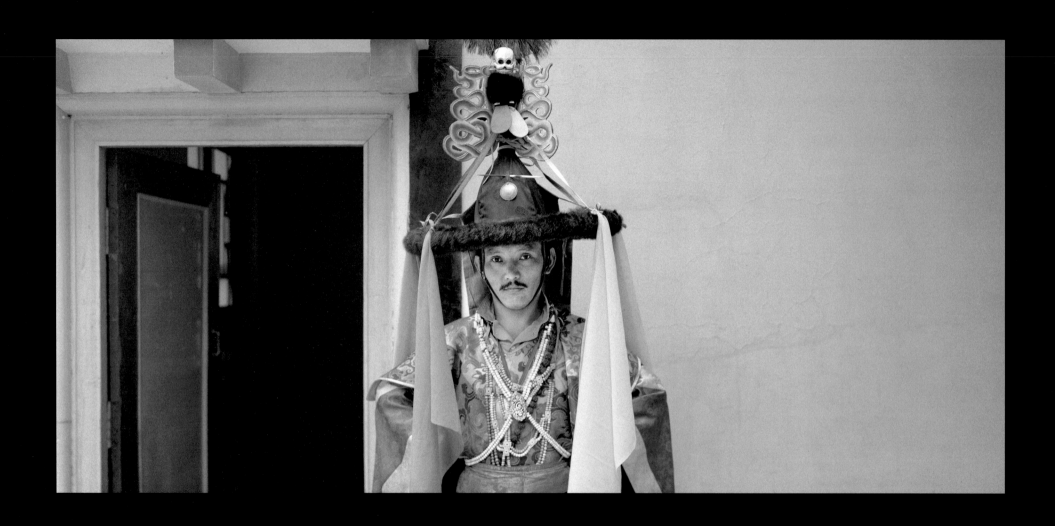

Black Hat Dancer, Tashi Jong Monastery

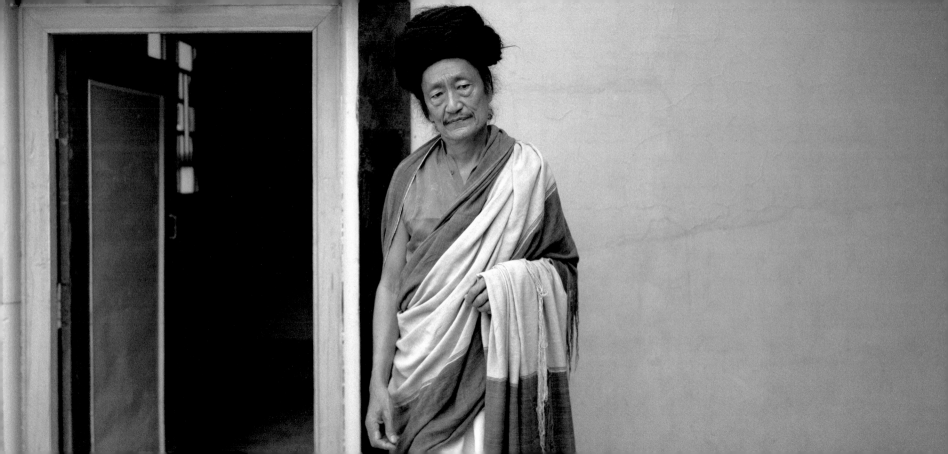

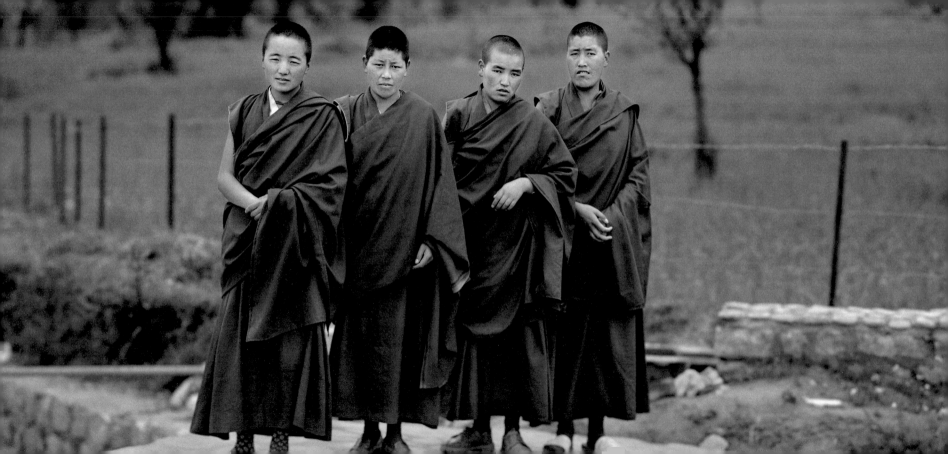

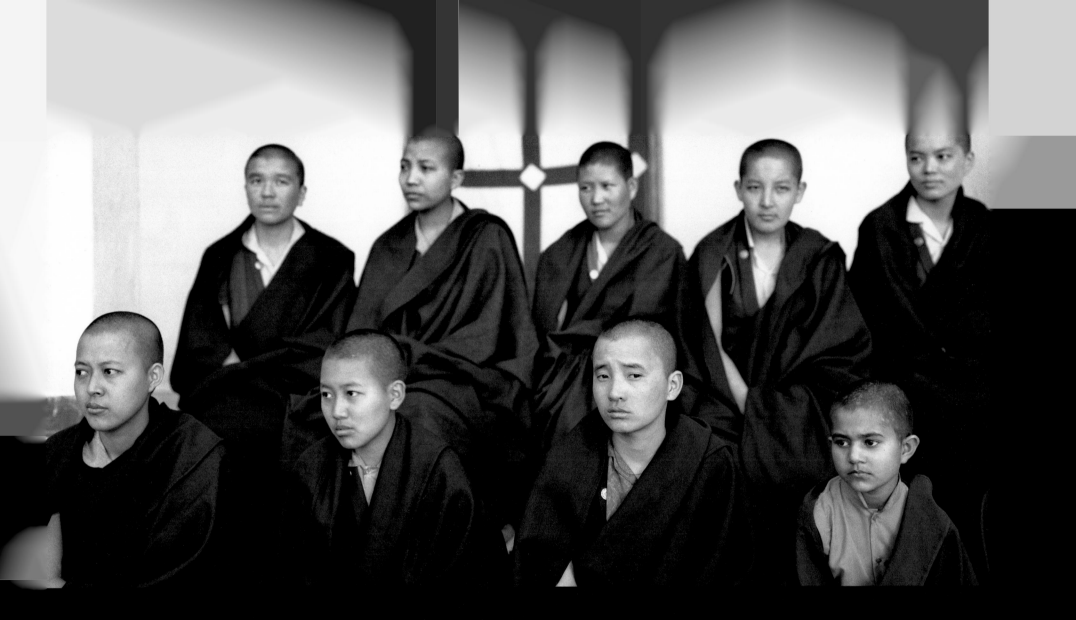

Monastic Gathering, Clementown, India

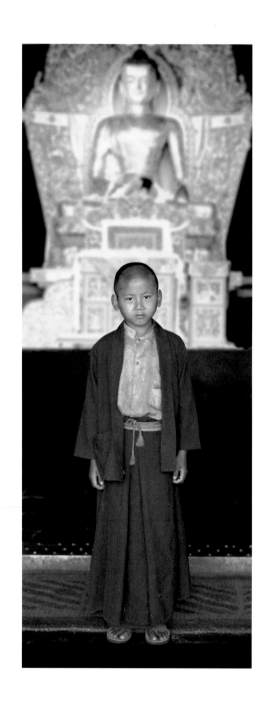

Child Monk, Dharamsala, India

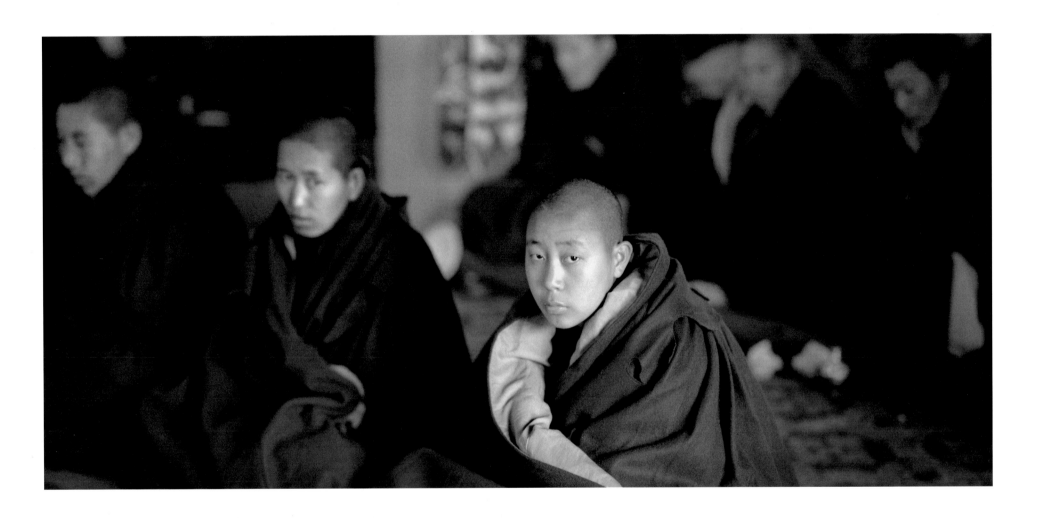

Nun during Prayers, Dharamsala, India

OLD TIBETAN WOMAN

My name is Samchok and I am one of the old people. To be old is to be revered among Tibetans because age is always a sign of wisdom. The respect is not earned but is an essential part of Tibetan culture. Tibetan elders are always respected regardless of what they did in their lifetime. Age alone is worthy of respect.

I am also a weaver at one of the Tibetan settlements in India and I work every day at weaving. We have no retirement here, as we have important duties to perform and much work to be accomplished before we die. I enjoy my work and the little money that I earn. As old people we are taken care of by the community. We are not left to be alone and we perform an essential service.

My family is nomadic, from central Tibet. Before my mother married, she was a nun. It is an existing custom in the area in which I grew up that if a woman is a nun and later on gets married and has a baby girl, the daughter must take her mother's past place in the nunnery. So I became a nun for thirty years. When I arrived in India in 1962, I was no longer a nun. I met my late husband here and we had three children. We faced many economic hardships and we worked in road construction doing heavy manual labor for decades.

My spiritual practice is very important to me, for I am preparing for my future life as old Tibetan people do. I perform my prayers as much as I am physically able throughout the day. I still cry when I think of my husband, whom I miss, and the many difficulties in my life.

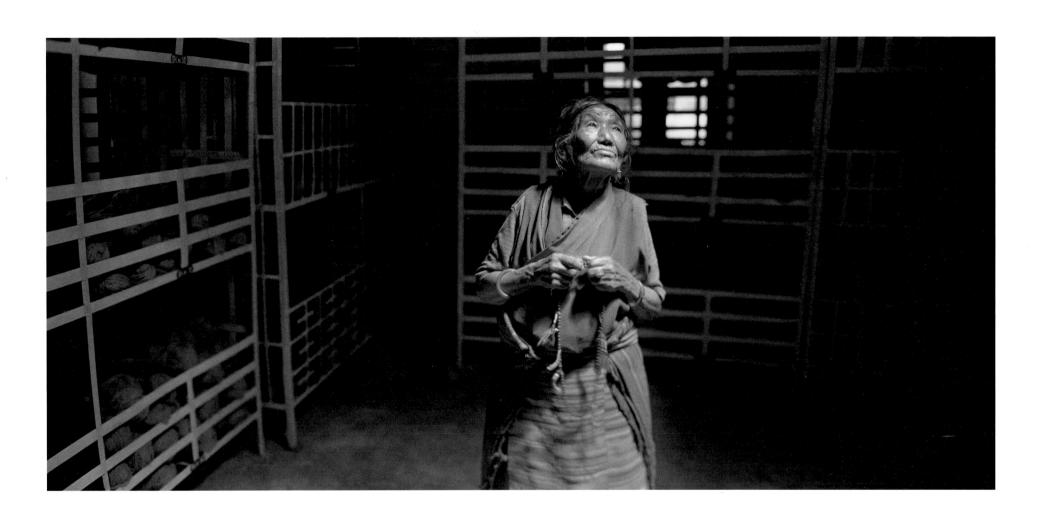

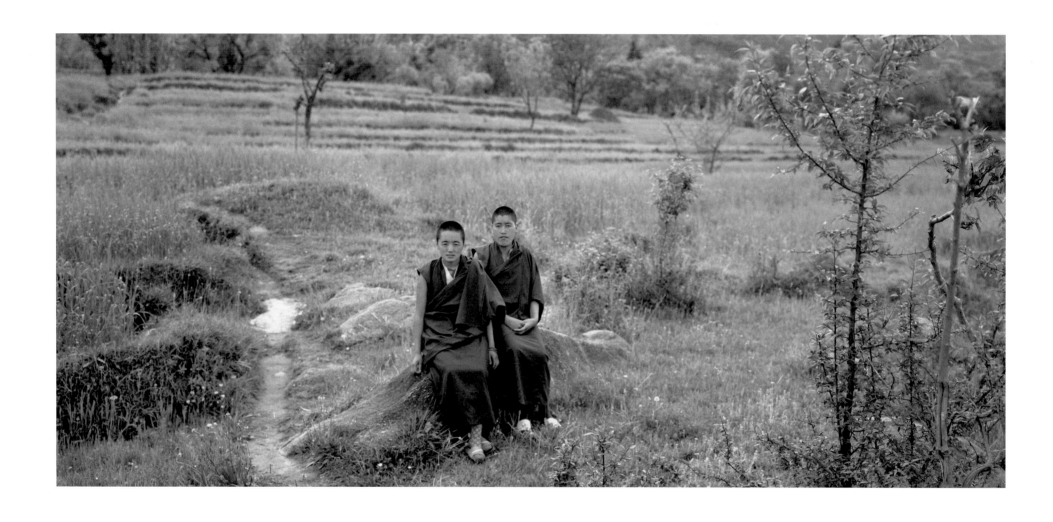

FINDING PEACE IN PERSECUTION

We feel it is our duty as nuns to keep focused on the attitude of compassion and kindness that is the very heart of Tibetan Buddhism. We intend to observe the humanity, the Buddha-like nature, inherent in all mankind. Life is a mystery to be lived, and we have devoted our lives as nuns to this single strand of our existence, which we believe to be true. We also feel it is our duty and responsibility as unmarried individuals to speak out firmly and peacefully not just for our country's freedom but for the freedom of all human beings. One day, five of us demonstrated with freedom placards against the Chinese occupation of Tibet. We were imprisoned for three years.

During our imprisonment, as we were being beaten, we focused our minds repeatedly on thoughts of peace. We sought to maintain the vision that here in front of us were other human beings who, like ourselves, were caught in a certain predicament and web of life. The guards' actions were based on understanding and knowledge which, from our point of view, were merely misguided and uninformed. They were beating us because they mistakenly thought we were different and consequently evil. The beatings were thus their attempt at education and their misguided attempt at reforming us.

We in turn were equally determined to see the guards as ourselves, as fellow human travelers, for the reason that we always try to cultivate such an attitude as part of our religious practice. We thus brought our minds and hearts over and over back to the concept of peace. We sought to maintain our Tibetan vision of the preciousness of life, which is something we have learned and have been trained to do. We wish to dedicate our lives to establishing this single perception because we feel it has ultimate merit and reflects the truth. We want peace in the world, and the first step, as we see it, is to put our own house in order, to act peacefully and with the grace of being. We did this during the three years of our imprisonment to the best of our ability.

Ten Thousand Prayers

My name is Tsering Wangmo and I am seventy-five years old. I come from a farming family in Tibet. My marriage was arranged when I was twenty-one years old, and my husband and I escaped into India in 1962 without any problems. We were very lucky. When I arrived in Dharamsala, I did road construction work with other Tibetans. Women were expected to do the same work as the men, so for the next thirty years I carried bricks and rock. I worked in the hot summer sun and in the winter with snow up to my waist.

As time passed, my husband became ill. He always had problems with the weather and the food. He worked too hard and finally he died. We had nine children during our marriage. Eight of my children died from polio, except for my last daughter, who died five years ago. I am the only one left now. I feel very sad. I feel alone and I have suffered my entire life.

When you ask me if I feel angry at the Chinese government for what they have done to Tibet and the Tibetan people, I say, "No, I do not feel angry because nothing good can come from anger." When I weave, I pray. And when I don't weave, I also pray. I pray for world peace and I pray for the long life of His Holiness the Dalai Lama. I try to do ten thousand prayers for world peace each day. I count these prayers on my prayer beads.

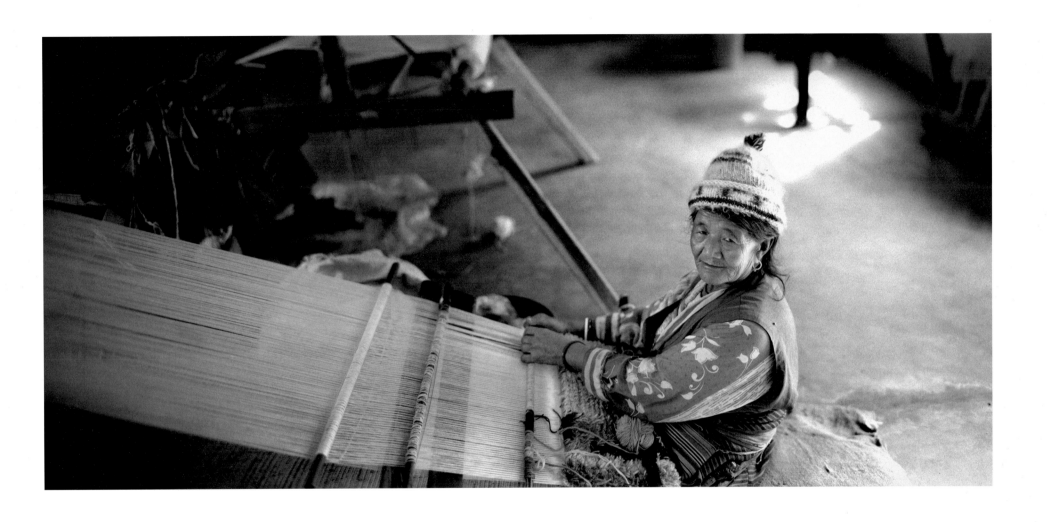

THE ENHANCEMENT O

THE MIND

In Dharamsala, I had heard about a grassroots English language school, and one evening I set out to see it for myself. It was raining as I fumbled going down the path trying to find the classroom. I did not have a flashlight and I could not see anything at all in front of me because it was so dark and the descent was so steep and rocky. Many parts of the tortuous path were missing altogether. The young people who accompanied me grabbed both of my arms from either side to keep me from falling. Ten minutes later I reached the bottom of the path and faced a concrete building that was to be a school. I opened the door and a muffled loud roar of voices instantly met my ears. My eyes immediately met the familiar faces of two American teachers amidst at least two hundred refugees dressed in a variety of torn and tattered clothes. It was so noisy that I had to strain to hear the teachers' voices at all because many classes were held in the same room at the same time. There were no blackboards, chairs or even any floor mats to sit on. Everyone sat crouched together on the damp concrete floor, elbows against elbows. The room was dark and dank and it resembled more the decor of an old and neglected New York City subway station than a classroom. It was freezing cold. My senses assailed me and I felt like I was in another world.

All of these people were assembled here for a class in English, many having traveled from miles away. One Tibetan I met literally ran up the three thousand feet of altitude each day after work to attend this one-hour class. This made little sense to me. The usual incentives for receiving an education are missing in India, for there are so few jobs available. The future is dim in terms of economic gain. Why? Why then were all these refugees attending this class? And yet, here they were scattered before me. Hundreds of refugees struggling to learn English and defying what seemed to be common sense. I would have thought of education as a useless luxury in such a jobless world. Apparently not. Nomads, farmers, young adults and children were all working away to enhance their minds. It was something to be proud of. "I want to learn," they nobly exclaimed. "I am here to get an education."

This was only one example of the intellectual thirst I encountered. Many of the young adult nomads and farmers I met had traveled for months over the Himalayas in search of this same something called "education." I always asked them why they made their long journeys. The longing for education was the most frequent answer. But it constantly intrigued me how nomadic people could even know what education was, let alone be motivated to travel over hundreds of miles of mountain terrain in winter in pursuit of it. From whom did they learn about its existence? So I kept asking them how they had learned about education. "Oh, from friends…from my uncle…from my mother…or father…," they responded.

I met many mothers and fathers who had saved what little money they could for years and then either sent their children with a guide or brought them personally over the Himalayas in order that they receive an education, only to return home to Tibet to tend their farms alone. "Are you sad to leave your children behind?" I would repeatedly ask. I noticed that they looked puzzled and surprised at the question. They did not seem to know what I was talking about and viewed the question as nonsensical. I continued to ask about the elusive sadness my experience had led me to accept, and they continued to be

puzzled at the absurdity of my questions. In the end, it was not the case that sadness was absent. Obviously, mothers and fathers were sad at leaving their children behind. But the focus of the Tibetan parents was on the possibilities for a more glorious and educated future for their children. It was like seeing the glass of water as half full rather than half empty. The Tibetan parents were seeing the possibilities and not the losses. The fact that their children would receive education and opportunities that they themselves never had was their source of delight. Over and over, parents described the joy of giving their children the precious gift of education. Over and over, the thirst for knowledge, the hunger for mental enrichment, and the honor of having an intelligent and educated member of the family were evident.

Whether religious or secular, the yearning for fuller knowledge and understanding was the same. Many, if not most, of the thousands of monks and nuns who had traveled to India did so in order to learn more about their Tibetan Buddhist religion. It was the same desire for mental sophistication, to master even some small aspect of the world about them.

And so I came to realize that the desire to learn, this craving for education and the nurturing of the mind, is something fundamental in our species. The old adage "What you don't know won't hurt you" is simply not true. What we don't know does hurt us and others as well. Ignorance is never bliss. Ignorance is painful and empty. It is uncomfortable and it is the root of tyranny and cruelty. The thirst for education is something intrinsic, essential and satisfying. It is not a luxury. It is the very essence of our humanity and the root of our civilization.

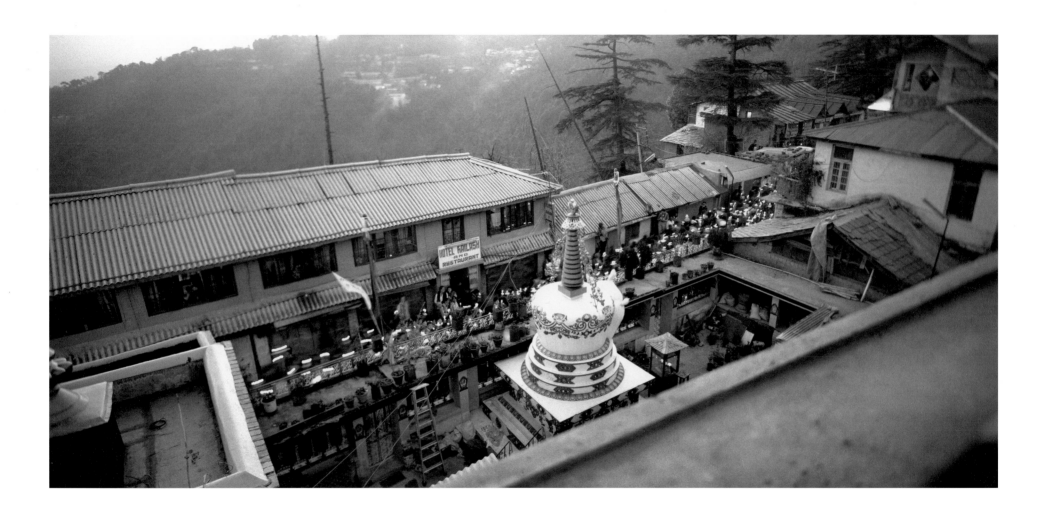

Candlelight Demonstration, Dharamsala, India, Celebration of Tibetan National Uprising Day against Chinese Rule

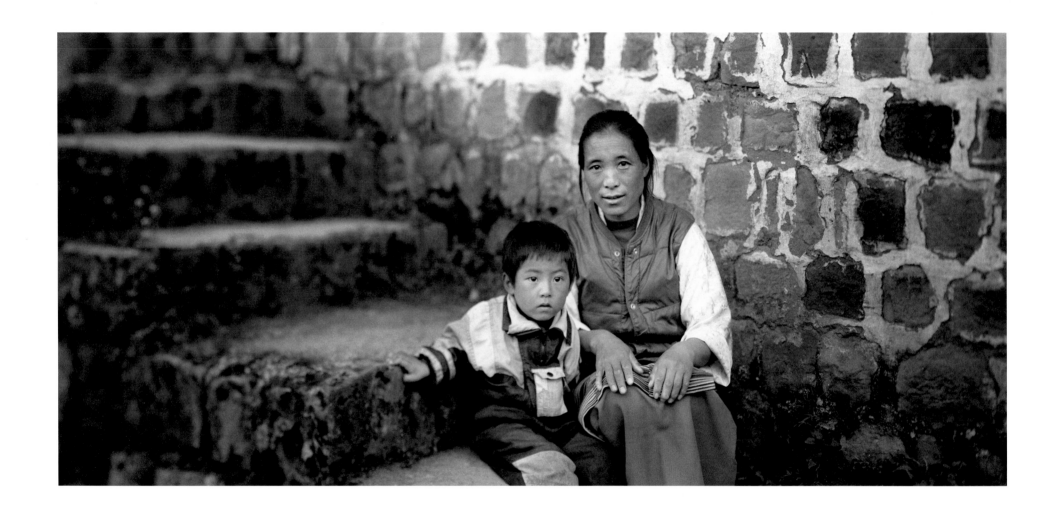

THE WOMAN WHO SOUGHT HER SON'S EDUCATION

I am thirty-eight years old and I have just arrived with my three-year-old son from Tibet. I decided to leave my home because it was time for my child to go to school. The education is inadequate in Tibet because it is taught by the Chinese. They brainwash children and teach what is not true. It is important that my child learn about his Tibetan heritage.

It took me five years to save enough money to leave and pay for our long journey to India. We traveled alone by bus to Mt. Kailash, which took seven days. I then paid a guide and we were able to join a group of eighteen other people. There was only one other woman who had a child in this group. The remainder of the group consisted of monks and nuns.

From Mt. Kailash it took our group two months of walking to reach Nepal. It was winter, but we were fortunate because we had only two days of deep snow. I carried my child on my back with our bedding and food. I had no other clothes or shoes other than those that I am now wearing. It was very cold and I was always worried that my child might die. I prayed constantly that we would reach India and receive the blessings of His Holiness the Dalai Lama. It was this determination and the love for my child that kept me going. I will be very sad to say good-bye to my little boy, but I feel I have no choice. Dharamsala is already overcrowded with refugees like myself who cannot find work. I will have to move on to somewhere else, leaving my child behind.

THE AWAKENING

When I was eighteen years old, I entered the monastery to become a monk. Until that time I had been brainwashed in the Chinese schools. By that I mean as children we were exposed to very limited true information. What passed for education was really propaganda and Chinese ideas. How is one to know that they have been brainwashed if they have nothing to compare it to? As young people, we did not know other than what we were taught. I did not know Buddhist philosophy, and my parents had never told me the truth about our homeland because all Tibetan parents are afraid of their children revealing such information. I was thus unknowingly indoctrinated into the Chinese way of thinking.

One day I accidentally noticed a book in the drawer of one of my friends who was also a monk. It was titled *My Land and My People*, and it is the story of the Dalai Lama's life and includes information about Tibetan culture and history. My friend had received the book from a Westerner, but he would not let me read it because he was afraid. We had to be very careful who we were talking to because there was always the fear of espionage. One evening I finally persuaded him to release the book to me for just seven hours.

I bought many candles and pulled the curtain across the window of my room. I made sure the door was locked from the outside by my friend and from the inside by myself. I stayed up all night reading that book. Tears streamed down my face as I came to know about the tragic fate of my country and its people. I wept and wept. Everything suddenly fell into place, and I realized the Chinese had kept us away from so many truths.

This one night changed my entire life forever; there would be no turning back. After reading this book, I realized the value of freedom and what the word "independence" really means. From that day on, I vowed to work for the freedom of Tibet and, if necessary, to sacrifice my life for the freedom of my country.

In due course, I was arrested for peacefully demonstrating in Lhasa, and I spent the next three years in Chinese prisons. I was brutally tortured and later through good karma received eight months of hospitalization in France for my internal injuries. I continue to suffer the physical effects of this brutality, but my love for my country has grown only deeper, and I continue to this day my vow to fight for the freedom of Tibet.

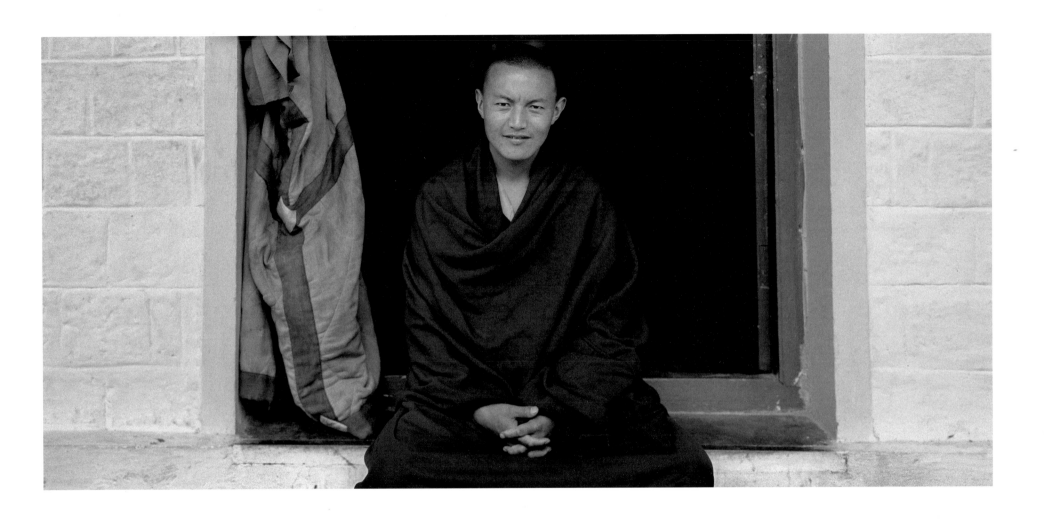

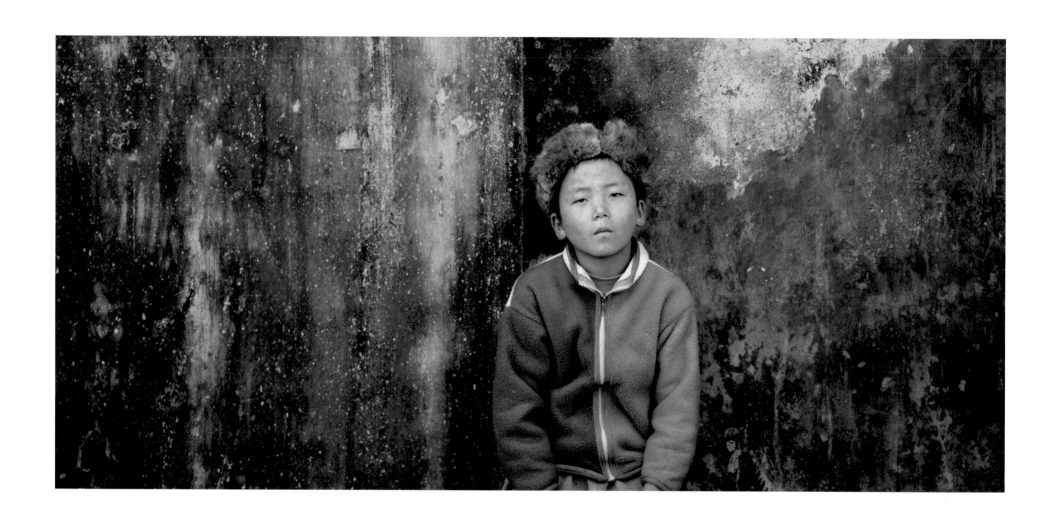

The Boy with the Fur Cap

I am eight years old and I have just arrived two days ago from crossing the great snow mountains into India with a group of other Tibetans. In Tibet, I was not able to get a proper education, so my parents sent me to India to study. My father is a watchman and my mother sells eggs on the street. Both of my parents feel it is important that I receive a good education.

I did not cry when I left my home in Tibet, nor did my parents. My younger sister cried a lot and that made me very sad. I was not able to tell even my best friends that I was leaving to go to India because they would not be able to keep my secret. Then the Chinese police would find out where I had gone and arrest my parents for sending me here.

I do not know anyone here and I miss my parents. I am remembering them from thousands of miles and I cry now when thoughts of my parents come into my heart. I want to study and become an educated person. Later on, I want to find a job. After that, it is my wish to return to Tibet to see my parents again.

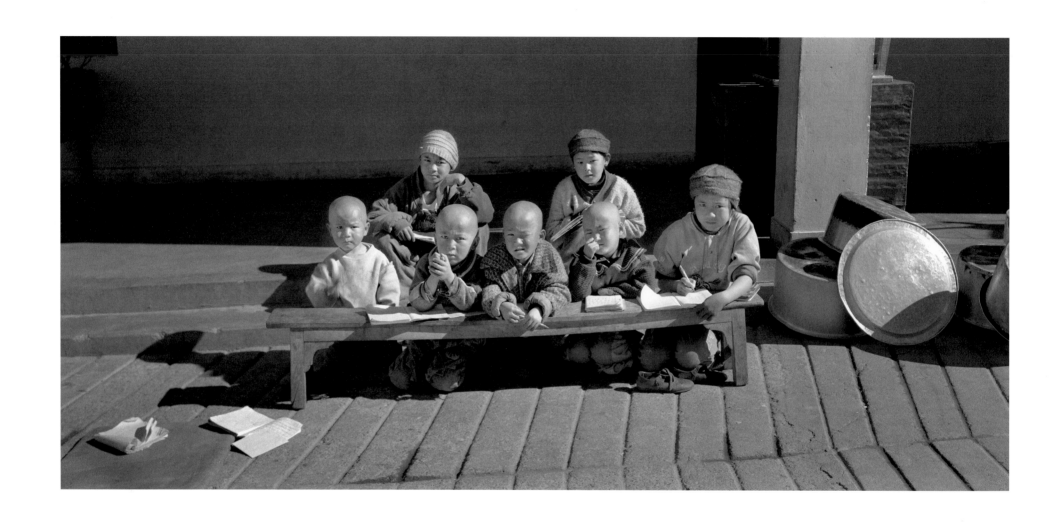

Children Studying, Tibetan Homes School, Mussoorie, India

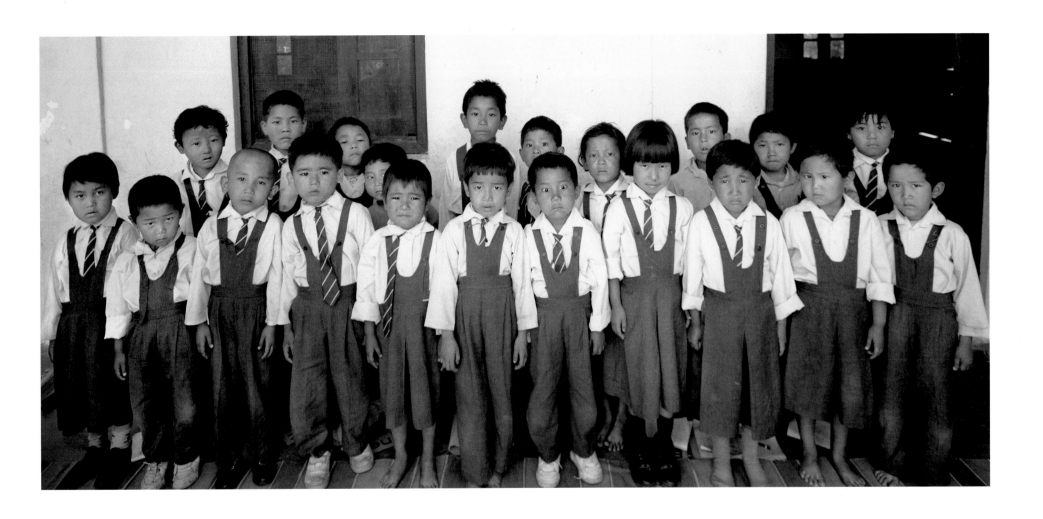

Schoolyard Portrait, Tibetan Settlement

The Young Man Who Wouldn't Give Up

I was just fifteen years old when I left my beloved family in Tibet. It was winter, and my best friend and I attempted to cross the Himalayas into India unprepared and without a guide. After three weeks we nearly died of starvation and had to turn back. We worked in Lhasa for the next year to earn the money to try again. I sold sweaters and my friend worked in road construction.

Our second trip, this time with a guide, was successful. When we arrived in India, I devoted myself to continuing my education. I quickly realized that the Chinese schools I had attended as a young boy had presented a very distorted view of Tibetan history. It was as if I had awakened from a dream as the knowledge of my Tibetan heritage unfolded in front of me for the first time in my life. My entire world opened up and I began to read all the Tibetan and Chinese history books that I could lay my hands on. My mind became alert and observant in ways I had not experienced before.

After a year of study in India, even though my education was incomplete, I knew I had to return to Tibet to inform my countrymen and -women of the same truths. My friend and I each carried sixty pounds of books across the same nineteen-thousand-foot Himalayan peaks we had originally come over.

During our return, in May of 1995, we were arrested in a small Tibetan village. Our crime was that we had gone to India and were now returning to Tibet. I was sent to one prison after another as the Chinese police repeatedly tried to make me condemn my country, an act I refused to carry out. Over the course of the next twelve months, I was sent to nine Chinese prisons, several of which were for the worst political criminals. I was the youngest political prisoner. Still, the Chinese police were unable to break me and I would reveal nothing.

When I was released in 1996, I felt like a dead person. My color was gray and I felt old and weak. I was placed under police surveillance along with my family. Finally, I decided that I must again escape to India. I left in the winter of 1997 with a group of Tibetans. I now live in Dharamsala, where I study with great determination to educate myself so that someday I can help in freeing my country.

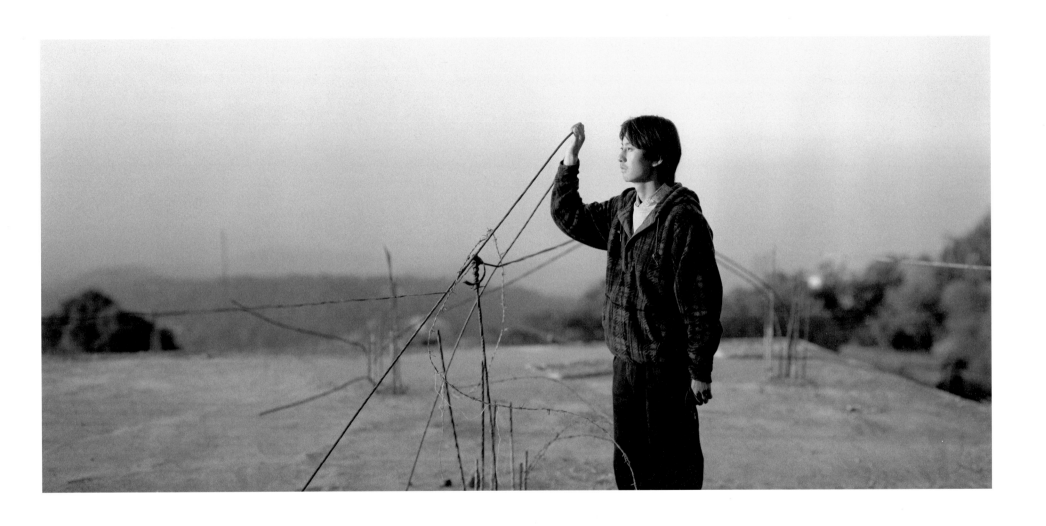

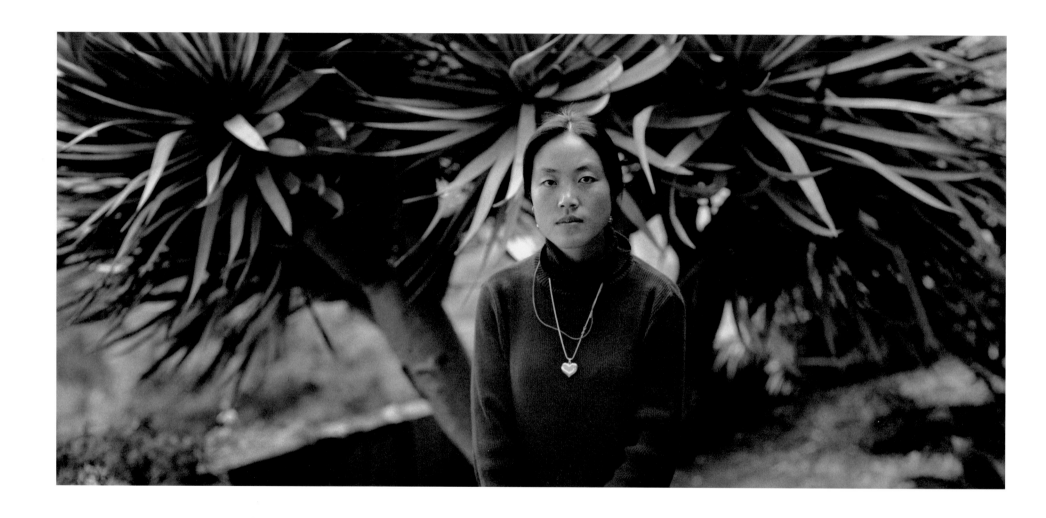

The Girl Who Found a Future

As a young girl in Tibet, I did not know that the idea of a future existed. I dropped out of school in the sixth grade because of the unbearable taunting of being the only Tibetan girl in an all-Chinese school. Of course, then it was expected that I would work in the furniture factory like my mother.

From then on, I went through life feeling like a blind person as I wandered about with no plans or goals and no imagination, or like a person who has been struck over the head and staggers about in a daze with no direction, falling this way and that. Having no purpose in living, I felt useless and thus had no confidence in myself. Like a frog trapped at the base of a deep well, I was sure the sky was small. I never worried about tomorrow because I did not know that tomorrow could be sought after or planned. To plan was to think the impossible and so my mind was dead and empty. With such emptiness comes pain and suffering. To remedy my pain, I escaped at the age of nineteen from nowhere to the unknown future. I sought an education in India.

Through good fortune and good karma, I now live in the United States. I am also married. Like the frog that was released from a deep well, never before in my life did I dream the sky could be so large and beautiful. I now have dreams, and I love the feeling of using my imagination and my mind. I am receiving an education and my thirst for learning is finally being quenched. I can look ahead, and I have aspirations and goals for my future. I am able to make plans, for there are opportunities and possibilities all around me. Such purpose and meaning brings me happiness for the first time.

THE ENDURING

CONCLUSION

The narratives presented in this book are portraits of individual Tibetans who tell the stories of their quest to attain more meaningful lives. The stories are true. The themes are common, and virtually every Tibetan has a journey marked by great personal tragedy and loss. Yet this book is not so much about torture, grief and the depravity of human existence as it is about human greatness and overcoming the effects of brutality and injustice. All the subjects in this presentation have demonstrated such heroic qualities as courage, fortitude and endurance. In spite of having suffered severe inhuman injustices, they have somehow increased their humanity. Altogether, they represent the extraordinary in humankind.

The fact that acts of ethnocide and genocide have been prevalent for so many thousands of years in every culture in every part of the globe, including our own, tells us that the villain lies within. The footsteps we follow are of our own making. Both the dark and the bright aspect of our human heritage coexist side by side within each of us, and the human mind is a symphony of potentials that sweep the entire spectrum from saint to sinner. From the worst of beings to the very best, we are all born of the same human fabric and are woven from the same loom.

The problem of cruel and violent action, whether in Tibet or in our own neighborhood, is a complex and universal issue. It has many levels of understanding. On a political level, the problem lies with the form of government we allow to exist and the leaders we permit to guide us. On an educational level, the problem is with illiteracy and the undeveloped mind. On a cultural level, the problem is with discrimination and prejudice. On a biological level, it is with the innate human fear of strangers and the inborn tendency to eradicate perceived human differences in our fellow human beings. On a societal level, it is with poverty, starvation and desperate living conditions. In the family, it is with child abuse and violent methods of child rearing. And on an individual level, it is with avarice, greed, power and fear.

The Tibetans thus give us a lesson in daily living when they hold so intentionally and resolutely firm to the principles of nonviolence, negotiation and communication. Despite the extermination of over one million of their fellow countrymen and -women, as well as the destruction and occupation of their beloved homeland, they continue to try and resist the more basic human urge of an eye for an eye and a tooth for a tooth. As a culture, they attempt to practice what they preach under the most brutal of circumstances. They are a living example of the fact that it is indeed possible for each and every one of us to strive to choose and to hold firm to principles and to embody noble ideals with noble actions.

And yet this book is, in another sense, not about Tibet at all but about the human condition. It is our story. It is about the respective journey that each of us must ultimately make in our own lives to better the fabric of our being. It is our search for meaning and tolerance. It is the story of how we want to live our lives and the effort and determination that we exert in the management of our minds. Anger, hatred and revenge as well as kindness, compassion and sensitivity dwell within each of us as human possibilities and are expressed in a wide variety of ways.

Thus the question each of us must ask is, How encompassing can our hearts be and how broad and tolerant will we allow our minds to become? For that is the ultimate skill in being human and that is the real subject of this photographic presentation.

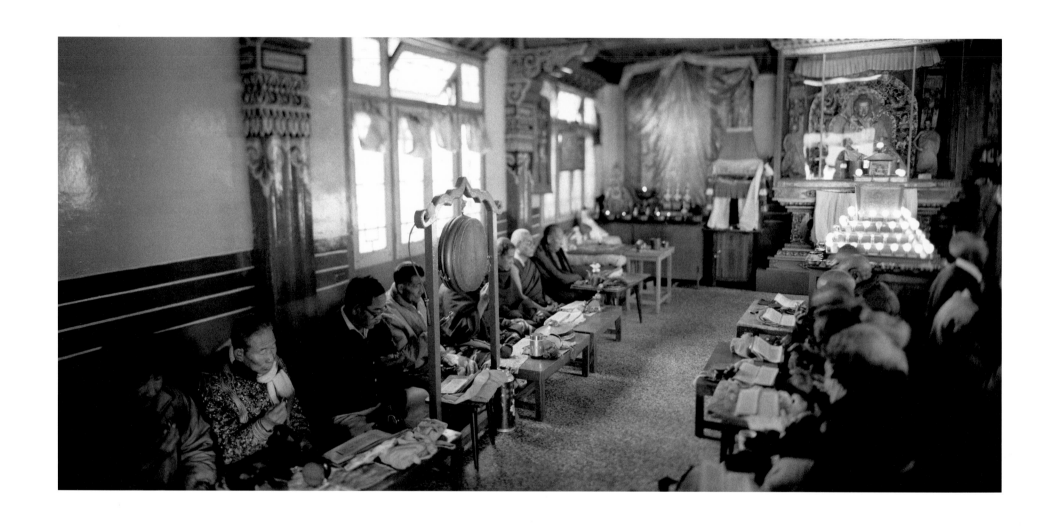

Prayers Being Offered in Temple, Mussoorie, India

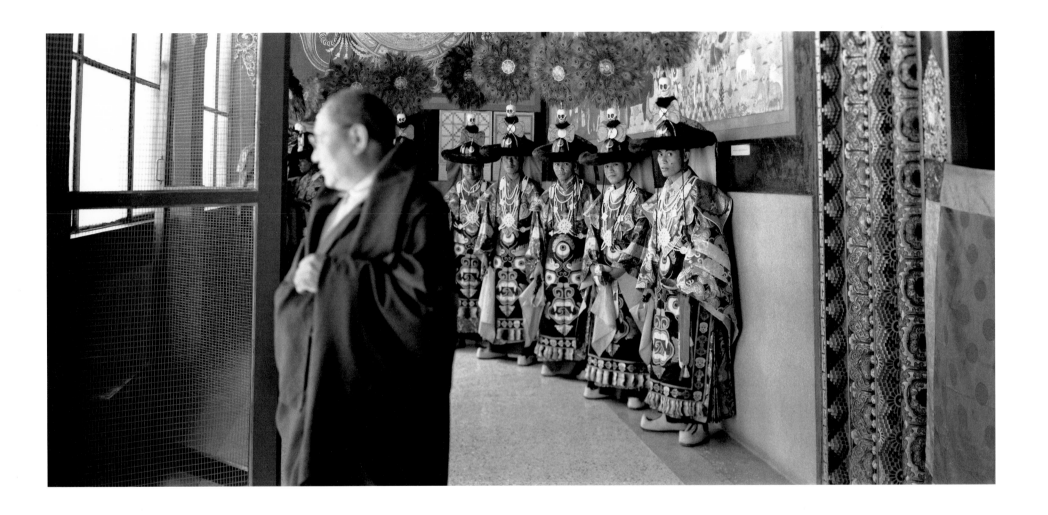

Black Hat Monastic Dancers, Clementown, India

EPILOGUE: THE PASSAGE OF TIME

It has now been several years since I began this project. In the interim, I have sponsored many Tibetan children, adults and families. I have participated in the founding of a school for refugees and have maintained numerous Tibetan friendships over the years. In the process, much of my enthusiasm with both India and Tibet has evolved into a more seasoned and balanced view.

It is perhaps ironic that I had to travel halfway around the world in order to be able to appreciate so much in my own life and country that formerly went unnoticed and was taken for granted. Among the Tibetans, I have experienced generosity that staggers my imagination. As a result, I am now able to be more generous, and the idea of providing social service has become an active part of my life. I have a better appreciation of what it means to live in a free world as well as to know the effects of cruelty and tyranny. I am absolutely convinced that ignorance, poverty and cruelty are highly correlated, and I have come to realize the absolute necessity of education. I have met many generous and heroic human beings. Their courage and self-sacrifice defy explanation. They serve to inspire my faith in humanity. I have seen and experienced other styles of living and I am more tolerant of cultural differences. I have a wider variety of models for dealing with specific situations, and I have more choices in my personal responses. Human rights is no longer just an abstract term that appears in newspapers, and as I listen to the news each day, I can feel and imagine the overwhelming agony that refugees the world over face. I have less glib interpretations in my professional life and have many more questions and far fewer answers than I have ever had in my entire existence. Life is indeed a mystery to be lived.

For Tibet, sadly, not much has improved at all. As of this publication, the United Nations continues to refuse to recognize Tibet as a country. The United States continues to grant China most favored nation trading status. And China continues its vigorous policy of cultural oppression and environmental destruction. Free speech remains virtually nonexistent. The Chinese technology of information extraction has become more sophisticated, and marks and scars are no longer left on the body, making human rights violations more difficult to document. There are far more Chinese in Tibet than Tibetans and there is always poverty because of discrimination against Tibetans. Drugs, alcohol and prostitution, once unknown in Tibet, are now common. Images and photographs of the Dalai Lama remain banned. The thin veneer of apparent life left in the monasteries is staged in large measure for the lucrative business of Chinese tourism and image management. The numbers of Tibetan children leaving their families to seek education in India are increasing. The endless numbers of refugees continue to silently whisper their prayers as they desperately pour over the Himalayas in search of a better life. Whatever the price, they can never be stopped, because the burning flame of the human spirit will never be extinguished by force alone.

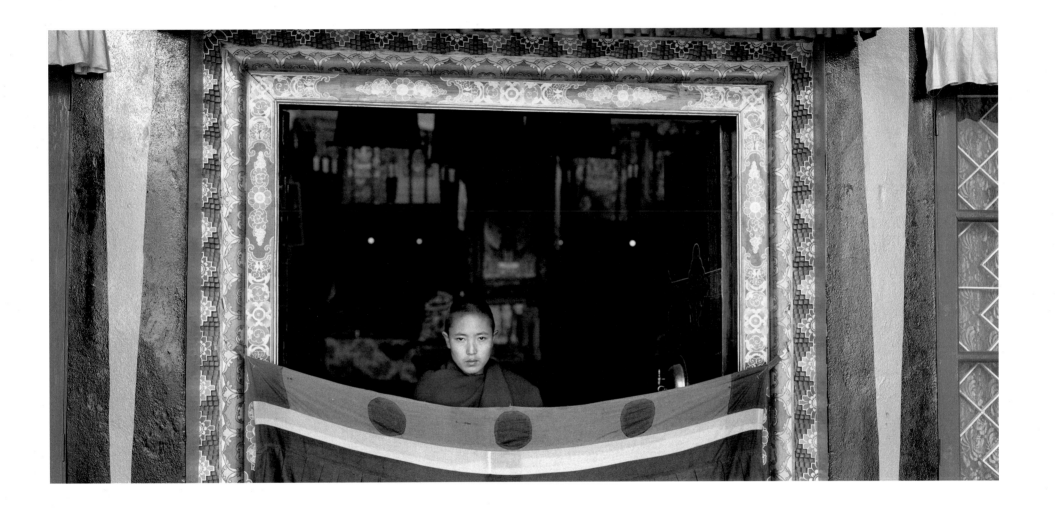

Nun in Doorway of Gandon Choeling Nunnery, Dharamsala, India

he real treasure, that which can put an end to our poverty and all our trials, is never very far, there is no need to seek it in a distant country. It lies buried in the most intimate parts of our own house; that is, of our own being. It is behind the stove, the center of the life and warmth that rule our existence, the heart of our heart, if only we knew how to unearth it. And yet — there is this strange and persistent fact, that it is only after a pious journey in a distant region, in a new land, that the meaning of that inner voice guiding us on our search can make itself understood by us. And to this strange and persistent fact is added another: that he who reveals to us the meaning of our mysterious inward pilgrimage must himself be a stranger, of another belief and another race.

Heinrich Zimmer, as quoted by Mircea Eliade in *Myths, Dreams and Mysteries*

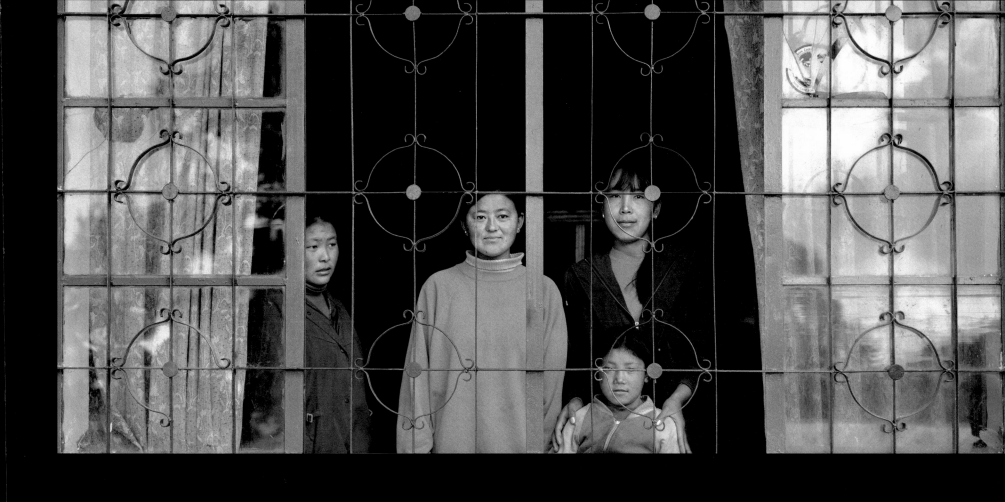

Window in Tibetan Homes School, Mussoorie, India

ACKNOWLEDGMENTS

One of the wonderful things about a project like this is that I have met so many extraordinary people and have had the privilege of working with them. Expressing my gratitude is my ultimate pleasure.

Arriving in a foreign land and, in a timely manner, gaining the trust of subjects who were to reveal sensitive personal stories would have proved impossible without the assistance of numerous people. In particular, many thanks to Sarah Lukas and the Friends of the Tibetan Women's Association, whose support in this project was crucial to its success.

The Tibetan Homes Foundation in Mussoorie, India, was most helpful in embracing me and allowing me to join in their community. It is my pride and pleasure to be able to continue that involvement to this very day. In particular, thanks to former General Secretary of the Tibetan Homes School, Pema Dechen Gorap, and to the present General Secretary, Thupten Dorje. Thanks to the school photographer, Buchung, for his guidance and assistance.

I wish to express my gratitude to the many children at the Tibetan Homes School who shared their thoughts, feelings and love for their beloved country. A special thanks to Tenzin Thinley and Nawang Losel, and to Sonum Dolma and Khando Yanchen, as well as Tsering Dolkar for her assistance in translation. Thanks to Kalsang Tsering for his informative letters.

Jane Perkins and Elizabeth Ferris, both dear to my heart, continue to be essential to the many doors that mysteriously swing open with a loud and sonorous boom to my presence and this project. Their encouragement was crucial. Thupten Samphel of the Department of Information and International Relations assisted me in locating Tibetans with different life stories, especially in the early phases of my project. Thanks to my many other Tibetan friends who contributed directly and indirectly to this project.

Translation comprises a formidable task, as each interview varied in length from thirty minutes to several hours. There were many dialects involved and many were difficult to understand and translate. Thanks goes to Lobsang Wangyal for his valuable assistance as translator. Written translation also comprised an added important part of my project. Tsering Yangkyi and Chime Wangmo were most helpful, and labored for what seemed to be an eternity in the tedium of these translations.

Thanks goes to Tsewang Dorjee and Dolkar Tso for their lively discussions, excellent translation skills and introductions to Tibetan life and thought.

In a project of this magnitude, some individuals have been crucial and deserve special recognition. Gail Kearns, my editor, is one of these. Gail's editorial skill, eternal optimism and perseverance far beyond the call of duty proved essential. Another crucial contribution was made by Michael Verbois and the staff of Media 27. Their dedication to this project was endless and is reflected in the refinements of the design and handsome presentation of this book.

Thanks to Vicki Goldberg and Anthony Storr for their important contribution to the essays contained herein. Thanks also goes to Matt Hahn for his original book concept design, to Meredith Boyd for her assistance and to Daidie Donnelley for her inspiration.

Applause is directed to so many of my personal friends who read and reread my manuscript and provided many valuable suggestions.

Very special thanks to my awesome eighty-two-year-old mother, whose editorial skills and acumen are still active and beyond her years. Thanks to my three daughters for their love and encouragement. Most of all, special appreciation goes to my wife, Jerri, for her unwavering support of this project. Without her encouragement and total faith in my abilities, this book would not have been possible.

TECHNICAL CONSIDERATIONS

PHOTOGRAPHIC AND IMAGE CREATION

The photographic images in this book were taken using a 7 x 17 inch Canham camera, which is a refined modern version of the old banquet camera used earlier in this century. I brought ten wooden film holders and three lenses: 120 mm, 355 mm and 450 mm. My backpack, fully loaded, weighed in excess of 65 pounds. I fashioned film changing rooms in the many hotel bathrooms, bedrooms and closets with black plastic and gaffer's tape. Natural light was always used, and exposure settings inside the dimly lit monasteries were typically around f/9 at 0.5 seconds. I used Ilford HP5+ film, which has an ISO speed of 400. The film was exposed and developed using the BTZS method of film exposure and development. In spite of my protests, the film went through security radiation at airports twice. On my return home, I developed the film with undiluted D-76 at 75 degrees. The images were then contact printed using platinum and palladium. For more information about this photographic project see *www.TalismanPress.com*.

INTERVIEWS AND NARRATION

Each subject was fully informed in Tibetan as to the nature of my project and the use to which the interviews and images would be put. I recorded most interviews on audiocassette; they were later translated from Tibetan into English. Language was always a problem due to the many Tibetan dialects spoken. Even the three Tibetan translators I hired had occasional difficulty in understanding the language of many subjects, as several were from remote nomadic regions. The interviews lasted from thirty minutes to up to ten hours. The location of these interviews was usually on rooftops of buildings, on the street or in hotel rooms. They were often done in the presence of friends and family, since privacy is so unfamiliar in this part of the world. Other problems in gathering the narration included translating Tibetan concepts and styles of thought that do not exist in western countries.

TRAVEL IN INDIA

I made a total of three trips and spent approximately four months in India making photographic exposures and gathering narrative material. Most of my time was spent in Dharamsala. When necessary, I traveled to various Tibetan settlements with the help of several competent hired drivers. My equipment was large and bulky and was lashed either to the roof or trunk of the vehicle, and it is a wonder that it survived without incident, given the condition of the roads, speed of traffic and the many flat tires. Along the way, I stayed in guest houses, hotels and private homes.

COLOPHON

Using Apple Macintosh hardware, the original 7 x 17 inch negatives were scanned on a Heidelberg Tango drum scanner at 600 dpi and separated into duotones using LinoColor and Adobe Photoshop. Photographic darkroom techniques, such as burning and dodging, were then applied directly to the digital files. Composite 300-line screen imposed negatives (film separations) were created on an Agfa Avantra imagesetter. The book was printed on 110 lb. book weight Reflections II. For more detailed technical information about the production of this book please visit *www.Media27.com*.

Creative production, pre-press, off-set printing, bindery, and general book production management by Media 27, a Santa Barbara, California based creative production company. *Whispered Prayers* was manufactured in the United States.

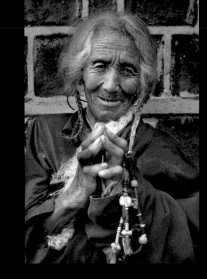

The central question for each of us is
how encompassing our hearts can be and how
broad and tolerant we will allow our minds to become.
For that is the ultimate skill in being human.

STEPHEN R. HARRISON